Interpreting
# CEZANNE

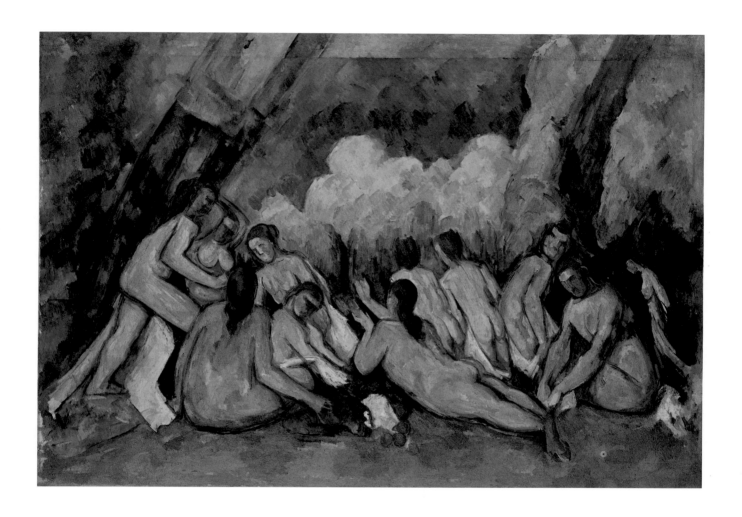

**The Large Bathers** 1894–1905, oil on canvas 127.2 × 196.1 cm
Trustees of the National Gallery, London

# Interpreting
# CEZANNE

Paul Smith

Stewart, Tabori & Chang
New York

# Acknowledgments

I am indebted to Michael Doran, John Gage,
Robert Ratcliffe, Richard Shiff and Richard Wollheim
for, variously, their comments on the manuscript, their
scholarship and/or their teaching. I am especially
grateful to Robert Ratcliffe for allowing me to make
use of material on Cézanne's theoretical sources from
his PhD. However, nothing written here is the fault of
anyone but myself.

Paul Smith

For Elena

Front cover: *Still Life with Green Melon* 1902–6
(fig.33) detail
Back cover: *The Great Pine* c.1889
(fig.42) detail

# CONTENTS

# INTRODUCTION

*One sees a picture at once, or not at all. Explanations are no use.*
*What's the point of passing comments? All that is only approximate.*

Cézanne reported by Joachim Gasquet

Interpreting Cézanne is no easy business. In the first place, the paintings themselves are difficult. Many works exhibit what look like distortions. They sometimes have a sketchy or unfinished quality. They often incorporate odd graphic marks. And they also seem to use quite arbitrary colours in places. For instance, in 'Still Life with Plaster Cupid' (fig.1), the cast itself appears twisted, the floor and some objects seem tilted up, some objects also slope to the left, and the apple in the background looks too big. The painting has many blank patches. It uses contour lines inside and outside the edges of objects. And its colours – like the green touches in the cast, or the red 'shadow' to the right of the green apple at the left of the painting – seem unnatural. For all this apparent confusion, Cézanne had coherent ideas about vision and about making paintings, and the difficulty his paintings present at first sight largely disappears when these ideas are known. Nonetheless, the artist's theories do not entirely explain his paintings, and some of his techniques only fall into place when the spectator can see a deeper coherence in his style.

However, it is not just the sheer strangeness of Cézanne's paintings that makes them difficult, but seeing Cézanne is also complicated by the fact that seeing always involves interpretation, or an attempt to bring what we look at within the scope of some familiar concept or category. (Unless a spectator does this, looking remains nebulous, and is not seeing, properly speaking, at all.) Thus, whenever we look at Cézanne, our ideas on art in general and Cézanne in particular – whatever they are – will inevitably condition how we see the work, or will predispose us to it under one aspect rather than another. It follows that a spectator's ideas enable him or her to see some aspects of an artist's work, but prevent him or her from seeing others by the same token. Put another way, seeing can sometimes be a kind of blindness, for which reason, it is important to approach the work with appropriate ideas.

Cézanne certainly knew this, and was wary of critics or artists misinterpreting his work according to their own agendas. In particular, he was suspicious of literary and philosophical interpretations of his art. That Cézanne did have these anxieties underlines the necessity of being cautious about accepting any interpretations of his art at face value. For instance, it is almost certainly the case that Gasquet's report of his conversation, with Cézanne, quoted above, is unreliable. For one thing, Gasquet was a poet (of sorts), and was given to purple prose; for another, he considered himself something of an intellectual, and had a tendency to represent Cézanne in a way that was inappropriate to his work and intentions. Similar problems beset many other accounts of Cézanne's art. And even the artist's own explanation of his work was sometimes less than consistent or complete.

All this raises the question of whether or not there is a right way of seeing Cézanne. On one view, there is not: there are simply a number of different ways of seeing his work. By this account, Formalist, biographical, psychoanalytical, anthropological and aesthetic accounts all have their own merits. However, each of

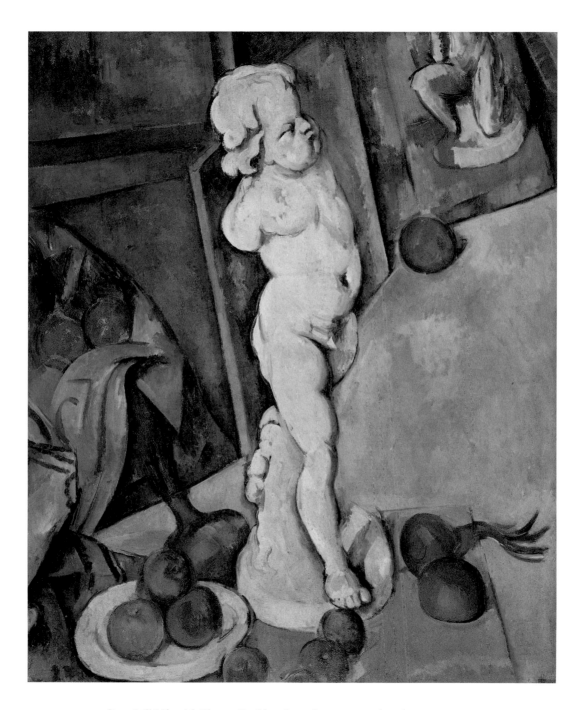

fig.1 **Still Life with Plaster Cupid** *c.*1895, oil on paper on board 70.6 × 57.3 cm
Courtauld Institute Galleries, London (Courtauld Bequest)

these ways of approaching Cézanne only reveals what it does by eliminating other dimensions of the work from view, and thus each is limited in what it can explain. Moreover, it is often the case that the different perspectives on Cézanne are irreconcilable or contradictory. For instance, seeing Cézanne in terms of psychoanalysis is at variance with more conventional biography, and a Formalist approach makes Cézanne into something that he would not have recognised. Thus, it cannot be that all accounts of Cézanne have equal validity.

Of course, not all approaches to Cézanne's work are designed to explain its character as art. And while this is not the only interest his work has, it is nonetheless an important dimension of it. To judge from Cézanne's 'conversation' with Gasquet, the artist considered that seeing his work as art involved seeing it rather as he did, since he designed it to embody visually a quality (which he called his *sensation*) that satisfied him. Much recent aesthetics also holds the view that an understanding of the artist's intention is necessary for seeing the painting as art, since the artist consciously and unconsciously (but nonetheless intentionally) brings it along so that it satisfies him by looking right. By both accounts, therefore, seeing the painting as art is a matter of imaginatively assuming the artist's point of view. Information about the artist's character, his techniques and theories, and his social world, may all be useful to the spectator who attempts to situate himself in the artist's shoes. However, seeing the painting as the artist intended is also, and more immediately, a matter of seeing it in its full complexity, or of finding how the work coheres to produce a particular effect. The spectator can test this idea for his or her self, in that a work can

change aspect, sometimes quite dramatically, when it does cohere – although this is most unlikely to occur at first glance.

One aspect of Cézanne's paintings that makes them interesting as art is the way they express (as well as represent) feelings connected with touching and being touched. For instance, in the 'Portrait of Victor Choquet' (fig.2), the painting holds together, rather as the sitter's hands do. Seen this way, the painting is expressive because it 'borrows' (or metaphorically possesses) bodily dispositions and feelings. In other words, it appears to have moods or feelings. Thus, seeing Cézanne as art involves seeing his work with feeling, or using feeling to explore it. It also means seeing the work metaphorically – as if it had qualities that we know it does not, but which we feel it might. All this suggests that all we may ever do is see the painting approximately, rather as Cézanne supposedly complained. (After all, to see something affectively and metaphorically is not to see it *as* something in a straightforward fashion.) It may even be that there is no readily available description for what we see when we look at Cézanne, and similar paintings; but this does not mean that such works do not merit the effort to find one. Indeed, on one view, it is because some works of art are difficult to conceptualise precisely that they are worth looking at and thinking about.

All in all then, the way we see Cézanne is largely a function of two skills: our ability to find some sort of coherence in the complexity and seeming confusion of the works themselves, and our ability to find an appropriate form of description for what we see. These skills are of course related, and in the best of circumstances, they enhance one another.

fig.2 **Portrait of Victor Chocquet** 1877, oil on canvas 46 × 38 cm
Columbus Museum of Art, Ohio: Museum Purchase, Howald Fund

# TRADITIONS OF SEEING CÉZANNE

## Formalism

*Treat nature by means of the cylinder, the sphere, the cone*
<div align="right">Cézanne to Emile Bernard</div>

Perhaps the most enduring tradition of interpreting Cézanne's work is Formalism. This originated in Symbolist circles in Paris in the 1890s, gaining wider currency through the writings of Roger Fry and Clive Bell in the early part of this century. In Bell's simple account, Cézanne's paintings were distinguished by their 'significant form', which, he claimed, produced a 'particular' or 'peculiar' emotion that he identified as 'aesthetic'. Although Fry's writings were more sophisticated, Bell's work popularised the idea that it was the surface qualities of Cézanne's paintings – their 'combinations of lines and of colours' – that made them aesthetically interesting. This way of seeing Cézanne was reinforced in the 1950s and 1960s when Clement Greenberg identified 'quality' in Cézanne's work with its 'purity', or the way it emphasised its 'medium' and the essential 'flatness' and the 'shape' of the canvas. Thus, Formalist critics could explain to their own satisfaction the peculiar 'distortions' of shape and scale and the unusual colour in Cézanne as aesthetic or decorative devices that the artist found in the process of working. However, they were wrong to identify Cézanne's particularity merely with its surface qualities, since doing so denies the interest Cézanne's work so plainly displays in pictorial space and the character that this gives to what the painting represents.

Cézanne's earliest expression of interest in space comes in a letter of 2 July 1876 to Camille Pissarro, in which he remarked of his motif at L'Estaque:

> It's like a playing card. Red roofs against the blue sea …
> The sun here is so tremendous that it seems to me that the objects are defined in silhouette, not only in black, but in blue, in red, in brown, in violet. I may be mistaken, but it seems to me to be the antithesis of modelling.

Decoded, Cézanne was saying that the highly coloured motif did not lend itself to traditional chiaroscuro 'modelling', and that it would better be painted in the new, colourist style he was developing with Pissarro's help. However, Cézanne also suggests that the bright sun, and the afterimages it created, caused the colourful and contrasty motif to look unusually flat, and thus prevented him from giving it a three-dimensional treatment. Something of Cézanne's struggle emerges in 'Landscape Study after Nature (The Sea at L'Estaque)' (fig.3), although the lighting conditions in this painting are rather different from those mentioned in his letter.

Formalist commentators have also seized on a remark that Emile Bernard attributed to Cézanne: 'Everything in nature models itself on the cone, the cylinder and the sphere.' However, although this seems to indicate the artist's commitment to an art of pure, or geometrical forms, there is no such implication in the letter from which Bernard culled this quotation. In this, Cézanne wrote:

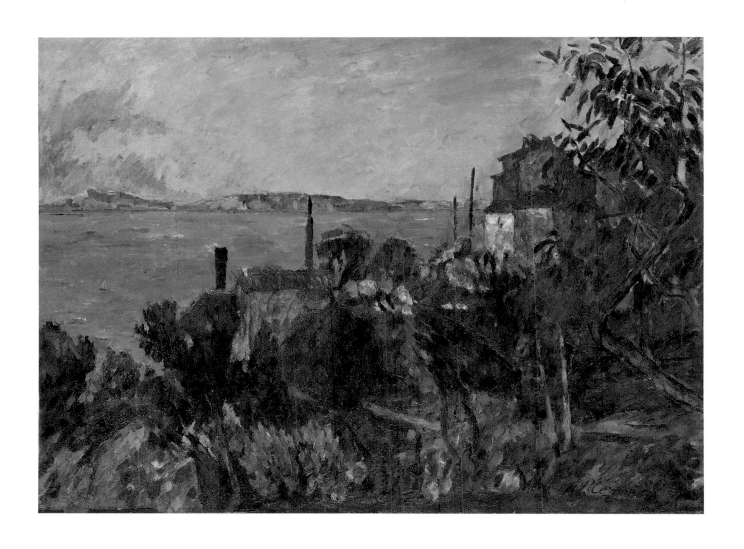

fig.3  **Landscape, Study after Nature (The Sea at L'Estaque)**  1876, oil on canvas 42 × 59 cm

Fondation Rau pour le Tiers-Monde, Zurich

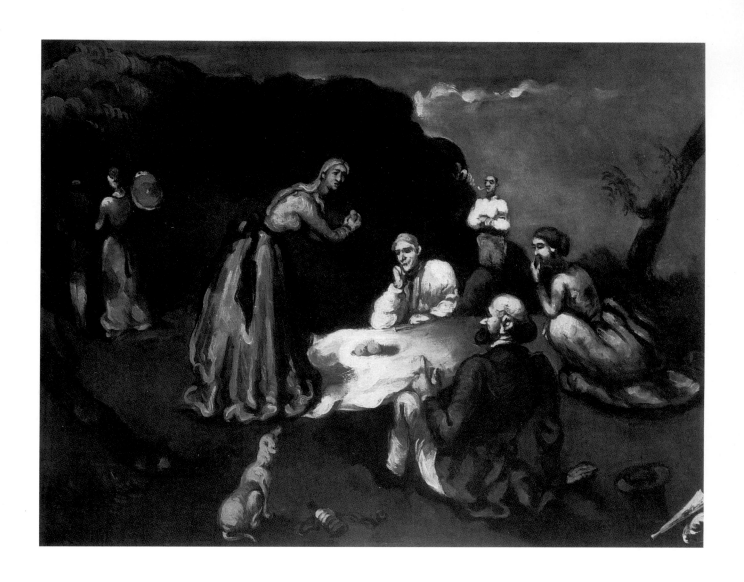

fig.4 **Luncheon on the Grass** *c.*1870, oil on canvas 60 × 80 cm

Private Collection

Treat nature by the cylinder, the sphere, the cone, the whole placed in perspective, so that each side of an object, of a plane, is directed towards a central point. Lines parallel to the horizon give breadth, or a section of nature, or if you prefer, of the spectacle that the almighty and eternal God the Father spreads before our eyes. Lines perpendicular to the horizon give depth – but nature for us men is more depth than surface, whence the necessity of introducing into our vibrations of light, represented by reds and yellows, a sufficient quantity of blueness, to make the air felt.

In effect, Cézanne was only trying to tell Bernard how to get 'depth' into his flat, decorative paintings (his words were actually a paraphrase of instructions in Jean-Pierre Thénot's *The Rules of Perspective Made Simple* of 1839). Admittedly, Cézanne did use quasi-geometrical forms in 'The Lac d'Annecy' (fig.5), but only to indicate objects prior to elaboration, as was standard Academic practice. Cézanne's real ideas on depth come in a remark recorded by his son and published by Larguier: 'Nature is depth'.

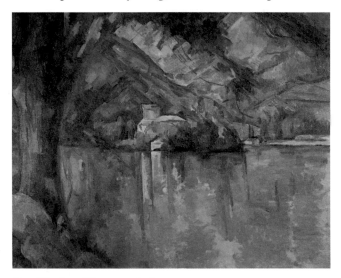

fig.5 **The Lac d'Annecy** 1896
oil on canvas 65 × 81 cm
Courtauld Institute Galleries, London (Courtauld Gift)

## Psychoanalysis

*I paint still lifes. Women models frighten me.*

<div align="right">Cézanne reported by Renoir</div>

Another way of seeing 'Still Life with Plaster Cupid' is provided by psychoanalysis. The model for most studies in this vein is Meyer Schapiro's psychoanalytical biography which aims to interpret Cézanne's paintings as if they were residues of subconscious urges and anxieties in the artist's psyche. Specifically, Schapiro sets out to show that the imagery of apples in Cézanne's still lifes is a residue of the artist's frustrated erotic wishes. In support of this contention, he points out how Cézanne was very inhibited when it came to sexual contact, and how many of his early works contain explicit and violent erotic fantasies. Schapiro also shows how apples play a role in many of Cézanne's early paintings with erotic themes, and how, in works like 'Luncheon on the Grass' (fig.4), they feature as a means of facilitating mixing between the sexes. In addition, he mentions how Cézanne, being familiar with Latin, would have known that apples figured as means of seduction in the work of writers such as Propertius.

Along similar lines, Theodore Reff's psychoanalytic treatment of Cézanne's work suggests that it is laden with anxieties that the artist felt as a result of his Oedipal relationship with his father. (Cézanne certainly was dominated by his successful father, and even kept his liaison with Hortense Fiquet hidden from him for many years.) 'Luncheon on the Grass' can be linked to the feelings Cézanne had about his father, insofar as a self-possessed older man in the background (smoking a pipe) watches the bald figure resembling Cézanne and inhibits his response to the woman's offer of an apple. Reff himself has linked 'The Feast' (see p.25) to Cézanne's feelings about his father. Working from a long poem called 'The Dream of Hannibal' which Cézanne wrote as young man, he argues that the

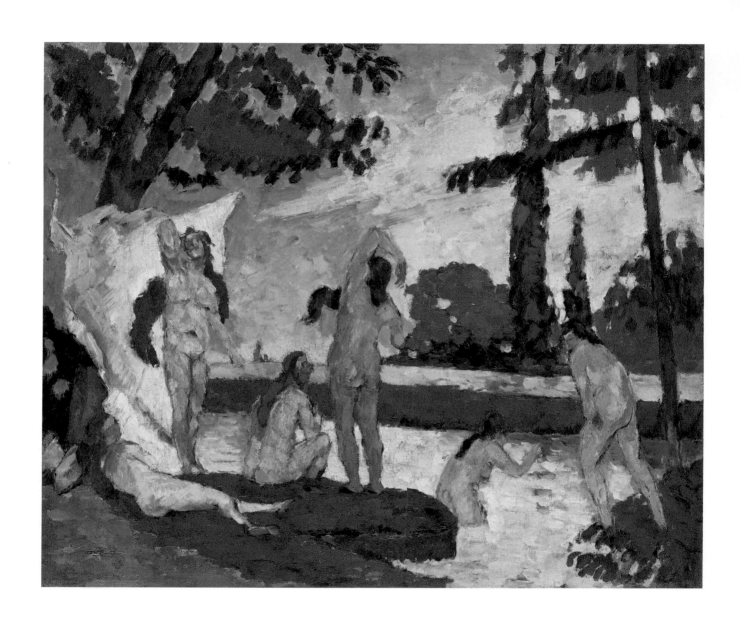

fig.6 **Bathers** 1874–5, oil on canvas 38.1 × 46 cm
The Metropolitan Museum of Art, Bequest of Joan Whitney Payson, 1975

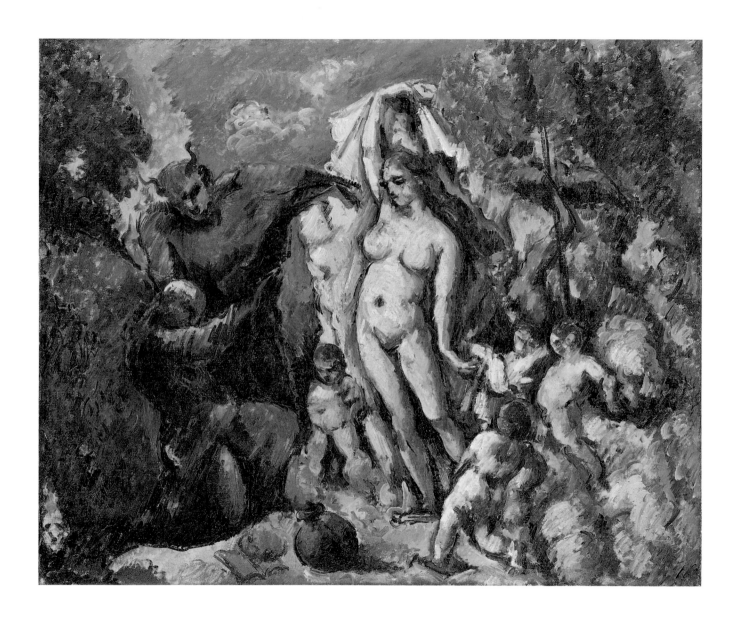

fig.7 **The Temptation of St Anthony** *c.*1875–7, oil on canvas 47 × 56 cm
Musée d'Orsay, Paris

excessive behaviour depicted in the painting expresses the guilt-laden fantasies about promiscuity, drunkenness and masturbation that troubled Cézanne as a result of his relationship with his father. He also points out how some of Cézanne's 'Bathers' (e.g. fig.6) had their origins in his paintings of 'The Temptation of Saint Anthony' (e.g. fig.7), and how this motif reveals the artist's identification with the tortured saint in Flaubert's story, who fled to the desert to escape temptation, only to be tormented by visions of a naked Queen of Sheba.

Psychoanalytical arguments have their merits and help explain, for example, why, even in late painting like 'The Large Bathers' (frontispiece), women are accompanied by fruit. However, it is a weakness of this sort of account that it ignores more straightforward iconographical sources for Cézanne's subject matter – for instance, 'Luncheon on the Grass' probably represents a scene from Zola's *Madeleine Férat* of 1868. A greater weakness is that it maintains that Cézanne was unaware of what he was doing. Yet in 'Still Life with Plaster Cupid', the artist contrasts Cupid with the picture of the flayed man in the background, just as it contrasts sweet-tasting apples and bitter onions, in order to symbolise quite deliberately how love is an ambivalent experience. Psychoanalysis also tends to be reductive in analysing paintings to subconscious psychic causes, as though they were dreams. It could be argued, by analogy, that a beautiful scent is no different from the bad smells out of which it is made – or that a peaceful and harmonious 'Bathers' is no different from the violently erotic 'Temptation of Saint Anthony' that is its source.

## Cézanne, his Intentions and his Style

*A priori, schools do not exist. The most important question is that of art in itself. Painting is either good or bad.*

Cézanne reported by Léo Larguier

Biographical writing on Cézanne can be identified closely with the scholarship of John Rewald, which has brought to light a great deal of information about Cézanne and his work. Unfortunately, this often fails to discriminate between what is relevant to the motives Cézanne had as an artist, and other facts. In essence, Rewald's is a residually nineteenth-century approach to art, and like the criticism of Cézanne's friend, Emile Zola, its goal is to get at the 'personality' behind the work. In one essay, Rewald even attributes Cézanne's 'genius' to 'paternal genes'.

Partly in the attempt to redress to this way of seeing things, Richard Shiff has reconstructed the motives and reasons available to Cézanne for painting as he did. He emphasises how Cézanne was committed to painting his *impressions* and *sensations*, and demonstrates that these concepts were not like their modern English equivalents, but were embedded in contemporary French Positivism (a scientifically grounded school of philosophy and psychology). In recovering the rules Cézanne followed when painting, Shiff uncovers the paradox that Cézanne followed quite precise, preconceived ideas about what *sensations* were, even though these, and the innocent vision that was supposed to go with them, were meant to be personal, spontaneous and untouched by culture.

The self-contradictory character of Cézanne's theory raises the problem of how it could help him paint. Richard Wollheim's aesthetics provide an answer in that this challenges the assumption that the artist's own account is the only or the best explanation of his work. Wollheim argues that the artist fulfils two roles when making the painting: he is, on the one hand, the agent

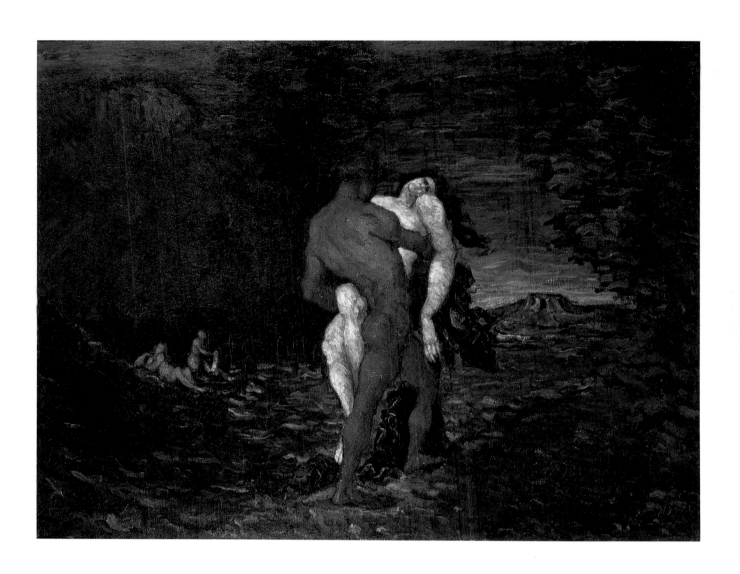

fig.8 **The Abduction** 1867, oil on canvas 90 × 117 cm
The Provost and Fellows of King's College, Cambridge (Keynes Collection) on loan to the Fitzwilliam Museum, Cambridge

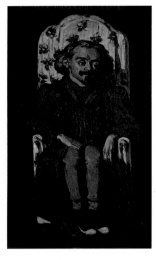

fig.9
**Portrait of Achille Emperaire**
1869–70
oil on canvas 200 × 120 cm
Musée d'Orsay, Paris, don de
Madame René Lecomte et
de Madame Louis de
Chaisemartin

of the painting; that is, he makes it. On the other hand, the artist is also the spectator of the painting; that is, he is the character for whose eyes he makes it. Thus the artist-as-agent might have certain conscious intentions that he thinks he acts out in the picture, while the artist-as-spectator is involved solely in bringing along the painting in a way that satisfies him – and perhaps also the spectators he imagines for his work. Crucially, the activity of the artist in his role as spectator does not necessarily involve him in verbalising about what he does. Thus, the artist may have an account of his work which only contains a partial or elliptical explanation of what he actually does. This means that Cézanne's conscious intentions are relevant to how his paintings look, but only to the extent that they actually facilitate the progress of the work.

Another consequence of Wollheim's theory of painting as an art is that the artist's mature style constitutes his main achievement. Conversely, the works he makes before his style is formed are only considered 'pre-stylistic'. (Cézanne himself had much the same belief as he told Louis Aurenche in a letter of 25 January 1904: 'the knowledge of the means of expressing our emotion … is only to be acquired through very long experi-

ence.') On Wollheim's view, style is real and is deeply rooted in the painter's body and psyche – which helps explain why it only comes to assume its mature character with the maturity of the artist.

It is possible to begin to substantiate these claims by distinguishing Cézanne's style from other features of his work that can be mistaken for it. For instance, Cézanne's early paintings, for all they are pre-stylistic, nonetheless exhibit certain consistent features. An example is the similarity between the right hand of the woman in 'The Abduction' (fig.8) and the loose hand of the sitter in 'Portrait of Achille Emperaire' (fig.9). However, this is not style. Rather as writing only gains a characteristic appearance when the child has learned to adapt letters one to the other and to the whole page, so an artist's style is not to be identified with details because it is a feature of the whole painting.

It could nonetheless be said that these two paintings have stylistic features in common, as they both employ a thick, tonally organised impasto to model forms. But, to identify this feature with style would mean that Cézanne employed a completely different style in his later paintings, which cannot be the case if a painter has only one mature style. Therefore, features of this sort are best explained with the idea that the painter tries out a variety of manners, or pre-styles, until he finds a mature style that is his. Along the way, a host of factors may affect his progress. In Cézanne's case these include the identities he tries out – the Provençal painter, the heir to the Old Masters, the modern painter – and his beliefs about the suitability of different styles to embody the 'temperament' or *sensation* he considered fundamental to good art.

Cézanne's work conveniently illustrates how style has a reality deeply rooted in the artist's character. The artist's penchant for violent erotic fantasies in early life is matched by the early manner he called 'spunky'. And it is a feature of both Cézanne's personality and his work that they moderate fantasies and accommodate

reality more as they develop. Moreover, Cézanne's style, like his personality, is less falsely synthetic and more properly integrated as it matures. The artist evidently understood something like this when he told Renoir: 'It took me forty years to learn that painting is not sculpture.' A comparison of the early 'Uncle Dominic as a Lawyer' (fig.10) with his mature works shows just how far Cézanne had to go.

A 'deeper' explanation of the development of Cézanne's artistic character and style is available in the theory of style that Adrian Stokes developed out of the psychoanalysis of Melanie Klein. Essentially, Stokes identifies two basic attitudes towards form in art – 'modelling' and 'carving' – which correspond to two kinds of attitude to the mother's body in infants, and which are foundational to object relationships in general in adult life. In this scheme, Cézanne's early work can be identified with modelling, inasmuch as this treats forms as relatively self-contained and unconnected with one another or the canvas. In contrast, his mature style is plainly carving, in that this corresponds to a kind of sculpture and painting in which forms are integrated with each other, and with the originating medium – the block or the canvas. It may be eccentric, but Stokes's argument at least suggests a source for the deeply affecting quality of Cézanne's mature style: the body. Also, its underlying assumption that carving corresponds to a character mature and complex enough to find a wholeness in itself helps explain how Cézanne's artistic maturity was late in coming, and was only achieved after a series of abortive efforts at a style.

Of course, Cézanne's artistic maturity involves more than his style, and embraces a network of relationships between his style and what his paintings depict. There is an obvious sense in which the painter's imagery is in his style, but a less obvious sense in which his style is in his imagery, or permeates it. It thus makes sense that there are many close connections between Cézanne's style and his imagery, apart from the obvious. For in-

fig.10 **Uncle Dominic as a Lawyer** 1866
oil on canvas 65 × 54 cm
Musée d'Orsay, Paris

stance, in works such as figure 55, objects like apples exemplify the body and express its dispositions and feelings (like human bodies, apples have skins, they stand or lean, and they have orifices and appendages). Some paintings use techniques which express bodily feelings, particularly feelings to do with touching and being touched. As Shiff points out, Cézanne's perception is also possessed of 'physicality', in that it often emphasises how things seen are available to the touch. Cézanne's style constructs and resonates with his imagery on a variety of levels, especially when the objects depicted in his paintings, and their manner of holding together, are taken as metaphors for feelings.

# CEZANNE'S FORMATION OF A STYLE

## Provence

*When one is born down there ... nothing else means a thing.*
Cézanne to Philippe Solari, 23 July 1896

Cézanne's search for a style was powerfully affected by his identification with his native Provence. Larguier records that the artist said 'The artist objectifies ... his native distinction', which suggests Cézanne concurred with Hippolyte Taine's idea that the painter's environment and race affected his way of seeing and his style. Cézanne certainly had a strong emotional and physical attachment to his native countryside of Aix. As a boy, he spent many a summer afternoon in the open air with his friends Zola, Paul Alexis and Baptiste Baille, reading Victor Hugo or Alfred de Musset, and hunting or swimming. Swimming remained Cézanne's favourite recreation in later life, according to an undated questionnaire in which the artist recorded various likes and dislikes. Thus the artist's own, very physical identification with the landscape enters the early watercolour of a diver, 'Woman Diving into the Water' (fig.12). It also survives in the late 'Large Bathers' (frontispiece), where the same figure reappears rotated through ninety degrees.

Cézanne regarded the collines Saint Marc outside Aix as the place that held the fondest memories for him. His letters also record his love for the Provençal countryside and suggest that this permeated his artistic tastes. For instance, in a letter of 3 June 1899 to his former school friend, Henri Gasquet, Cézanne spoke of 'the

old memories of our youth, of these horizons, of these landscapes, of these unbelievable lines which leave in us so many deep impressions'. And in a letter of 21 July 1896 to Henri's son, Joachim, Cézanne even spoke effusively of

the links which bind me to this old native soil, so vibrant, so austere, reflecting the light so as to make one screw up one's eyes and filling with magic the receptacle of our sensations, do not snap and detach me ... from the earth whence I have imbibed so much without even knowing it.

The fact that Cézanne's identity as an artist was deeply rooted in his experience of the Provençal countryside may perhaps be explained as an 'early' phenomenon: that when very young he projected his feelings onto it or 'smeared' it feeling, so that it came to be of a piece with these feelings, and thus expressed them. The resonance of the local landscape for Cézanne is certainly demonstrated in the way that the Mont Sainte-Victoire appears as a focal point of his paintings from the 1880s onwards (fig.11). It also appears in earlier works of the 1860s such as 'The Railway Cutting' (fig.13) and 'The Abduction', even though this represents the rape of Persephone, and the mountain in that case ought to be Aetna.

In 'The Abduction', the idea that Provence was a land where the erotic myths of ancient times had a residual existence must have infiltrated Cézanne's identification with the landscape. Quite obviously, this idea fed his erotic compositions, but it also informed the various 'Bathers' that developed out of these. However,

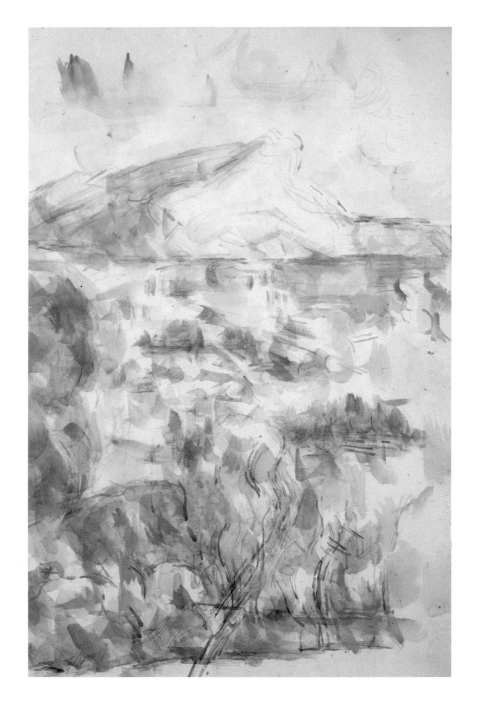

fig.11 **Mont Sainte-Victoire Seen from Les Lauves** 1902–6, pencil and watercolour on paper 48 × 31 cm
Philadelphia Museum of Art: Lent by the Tyson Estate

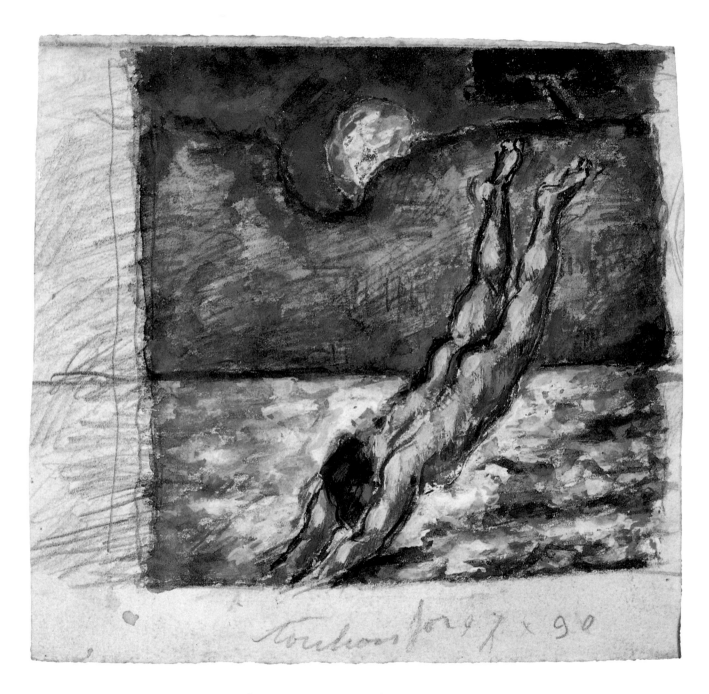

fig.12 **Woman Diving into the Water** 1867–70
pencil and watercolour and gouache on white paper 15.6 × 16.2 cm
National Museum and Gallery, Cardiff

fig.13
**The Railway Cutting**
1869–70
oil on canvas 80 × 129 cm
Neue Pinakothek, Munich

Cézanne's identification with the landscape changes considerably over the years. Instead of merely projecting fantasies into it, the artist learned to take a more peaceful and bucolic attitude towards it. Indeed, in a letter of 14 January 1885, Gauguin (somewhat fancifully) recalls Cézanne as a 'man of the south who spends days on the mountain tops reading Vergil and looking at the sky'.

Cézanne's identification with the Provençal landscape also shows how forming an artistic identity was a long, and far from straightforward, process for him. A good example of this is the way that Cézanne experiments in 'The Railway Cutting' (fig.13) with the overall luminosity and broad impasto of successful Provençal painters such as Paul Gigou and Emile Loubon, only to abandon this style, and then come back to it in his mature work. In a similar fashion, the experiments in open-air painting that Cézanne made in 1866 with his Aixois friends, Valabrègue and Marion, finally came to nothing. Thus, although Cézanne stated that 'all pictures painted inside, in the studio, will never be as good as those done outside' in a letter of 19 October to Zola about a picture of Marion and Valabrègue on their way to the motif, he admitted in a letter of 2 November that 'my big picture of Valabrègue and Marion has not come off'.

Cézanne's identity as Provençal also led him to emulate the seventeenth-century sculptor, Pierre Puget, who was born in Marseilles. He thought, for instance, that the bust of Cupid in the 'Still Life with Plaster Cupid' was by Puget (although it is now believed to be the work of François Duquesnoy or Christophe Veyrier). Cézanne's physical experience of the landscape entered this work inasmuch as he told Bernard: 'there is something of the mistral in Puget. That's what makes the marble tremble.' (The mistral is the strong, cold, dry wind that sweeps over Provence on its way to the Mediterranean). Here as elsewhere though, the mature Cézanne assimilates and transforms his source. Characteristically, he restrains the rhythmic energy of his model by making the entire painting harmonious and tightly knit, and by accommodating the silhouette of the sculpture to the rhythms of the whole picture. (Just how balanced the work is can easily be appreciated by reversing it, in a mirror for instance, when all the objects in the painting lurch violently to the right, and the floor appears to rise up as if to push back the vertiginously poised Cupid.)

23

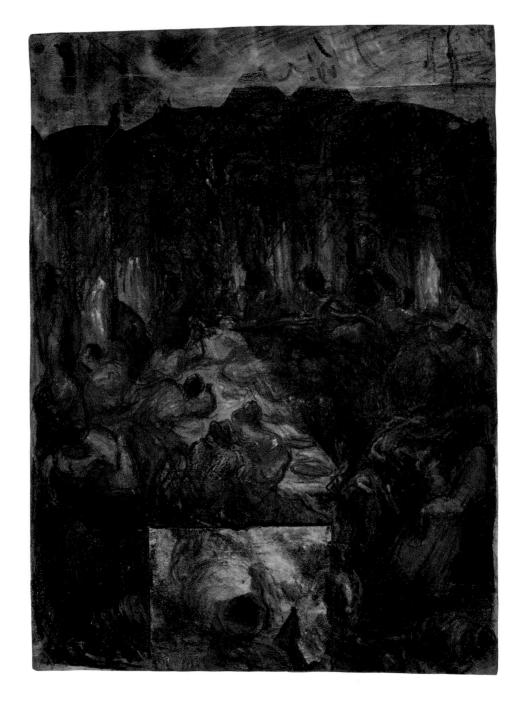

14 **The Feast** *c.*1867, pencil, pastel, gouache and watercolour on cardboard 32 × 23 cm
Private Collection, Stuttgart

## The Louvre and the Old Masters

*The Louvre is a good book to consult, but it ought only to be an intermediary. The real and prodigious study to undertake is the diversity of the picture which is nature.*

Cézanne to Bernard, 12 May 1904

Cézanne took an interest in a bewildering variety of Old Master paintings, and he studied them in a variety of media: in the original in the Musée Granet in Aix and in the Louvre, and also in the poor reproductions of the *Magazin Pittoresque*. His first attachment was to the forceful painting of the seventeenth century, particularly to the work of Mattia Preti and Jusepe de Ribera, and its strong chiaroscuro and sculptural quality infiltrate many of his early works, for example, the 'Portrait of Achille Emperaire' (fig.9) and 'The Abduction'. But as he matured, Cézanne came to reject this forceful idiom in favour of a more subtle style. And by the end of his life he identified strongly with the colourist tradition and particularly the Venetians, listing Rubens as his favourite artist, and in conversation making frequent reference to his admiration for Tintoretto and, particularly, Veronese. As Renoir aptly recalled:

> he thought he must force the effects of modelling with black and white and load his canvases with paint, in order to equal, if he could, the effects of sculpture. Later, his study brought him to see that the work of the painter is so to use colour that, even when it is laid on very thinly, it gives the full result.

However, early on, in 'The Feast' and the study for it (fig.14), Cézanne seizes on Veronese's use, in his 'Marriage at Cana', of contrasts of hue and of a deep perspective, to express the violent eroticism of his theme. (Cézanne also reworked 'The Feast' in Paris under the impact of Veronese's painting, which accounts for its overall luminosity.) In these borrowings, Cézanne identifies with an artist whose style expressed

fig.15 **After 'L'Ecorché'** 1875–86, pencil on paper 21.7 × 12.4 cm
The Art Institute of Chicago, Arthur Heun Fund

*force,* or the energy and strength he believed to be the source of originality. (He derived such ideas largely from reading Stendhal's *History of Painting in Italy* of 1817.) In his maturity, though, Cézanne took a radically different attitude to Veronese, and according to Maurice Denis, he drew on his 'Marriage at Cana' for its demonstration of how to unite the painting through contrasts, or form it into an integrated, harmonious whole.

In a similar way, Cézanne's mature identification with Michelangelo betrays his admiration for the 'feeling' Stendhal saw in his work, but also his own restrained and individual assimilation of this quality.

fig.16 **Bellona (after Rubens)** 1879–82
pencil on paper 48 × 30 cm, Private Collection

fig.17 **The Demon and the Damned (after Luca Signorelli)**
pencil and crayon on paper 24 × 18 cm, Private Collection

Cézanne's several studies of an anonymous 'Flayed Man' (fig.15), which he thought to be by Michelangelo, emphasise the feelings contorting the body, but they also contain these feelings in the way they accommodate the figure to the whole sheet. Rather as in his copies after Rubens's 'Bellona' (e.g. fig.16), it is as if the edge of the picture were the surface of the body, and thus the limiting surface of its feelings. In a like fashion, Cézanne assimilates Luca Signorelli's fifteenth-century work, 'The Demon and the Damned' (fig.17), in his later 'Bathers' (fig.18), but he tones down the *force* visible in the male body's musculature and suffuses this throughout the relationships of the whole painting.

A particularly interesting example of the dualism in Cézanne's identification with the Old Masters is the still life 'Bread and Eggs' (fig.19). Although this is an early work, it exhibits features of Cézanne's mature style alongside the forceful chiaroscuro imported from the Spanish Masters, particularly Francisco Zurbaran, and from the contemporary French painter, Théodule-Augustin Ribot. These mature stylistic features occur in the curiously rounded and twisted ellipse of the glass and in the tendency of the same object to slope or list towards the left. The source for Cézanne's use of such devices is Jean-Baptiste-Siméon Chardin's still lifes, which Cézanne studied in the Louvre and which he admired for their clarity of vision. However, there is no

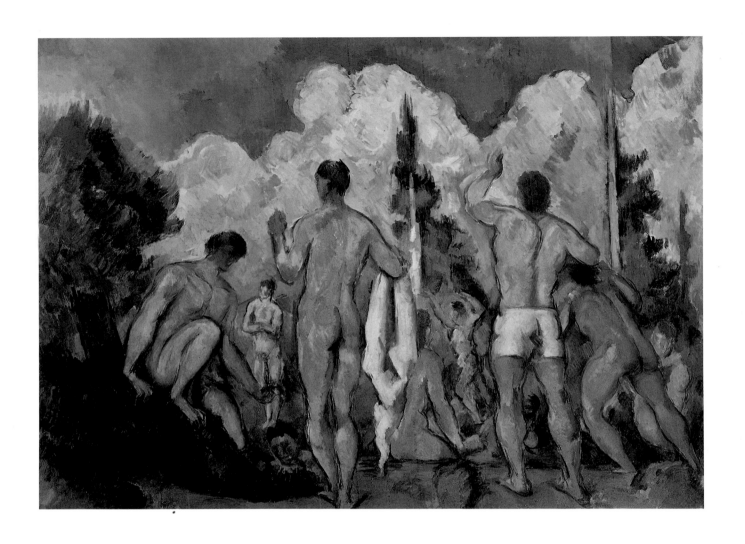

fig.18 **The Bathers**  *c.*1890, oil on canvas 60 × 82 cm

Musée d'Orsay, Paris, donation de la Baronne Eva Gebbard-Gourgaud

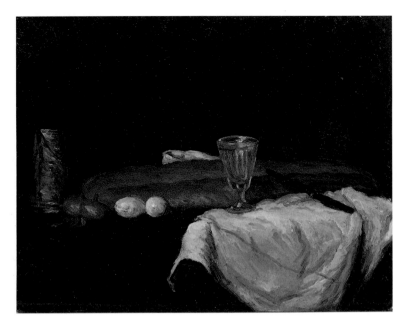

fig.19
**Bread and Eggs**  1865
oil on canvas 59.1 × 76.3 cm
Cincinnati Art Museum: Gift of Mary E. Johnston

easy explanation for why Chardin or Cézanne painted objects this way, save that this has the effect of balancing the painting as an optical whole. That is, 'distortions' like this give a coherence to the look of the picture that is often absent from works treated more conventionally.

There is little doubt that Cézanne modelled some of his work on that of Nicholas Poussin. For instance, Cézanne copied Poussin's 'Echo and Narcissus' and used one of its figures in the background of 'The Abduction'. He also copied one of the figures from Poussin's 'Arcadian Shepherds', and had of photograph of it on his studio wall. Cézanne's borrowings from Poussin are also evident in works such as 'Mont Sainte-Victoire Seen from Bellevue' (fig.20), which compares closely to Poussin's 'Landscape with the Ashes of Phocion' (fig.21). Cézanne takes from Poussin his use of a framing tree at the left of the painting, and his way of balancing the lines of the foreground trees against the silhouette of the mountain in the distance. (Cézanne

had mentioned his pronounced preference for 'balanced' lines in the landscape in a letter to Zola of 14 April 1878, and so his classical leanings developed early.) However, the real significance of Cézanne's interest in classical composition is that it allowed him a way of extracting a unified motif from the landscape with which he could make a coherent painting. As R.P. Rivière and J.F. Schnerb recall, the 'motif' was, for Cézanne: 'a section of nature encompassed by the [artist's] view, and thus isolating itself, and making a whole of what is a fragment'. Cézanne's Poussinesque devices also compress the space of the painting and link the foreground and background. Thus, when Cézanne told Bernard: 'Imagine Poussin entirely remade from nature, that's what I understand by classical', 'classical' arguably refers to the way that his style makes the painting hold together. Cézanne's Poussinism is not simply a surface quality, therefore. Rather, it corresponds profoundly to his mature artistic character and expresses feelings connected with touch.

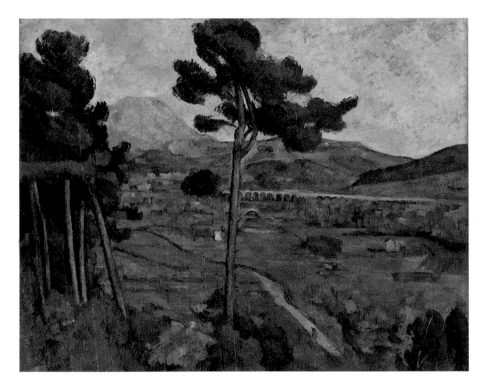

fig.20
**Mont Sainte-Victoire Seen from Bellevue**
1882–5
oil on canvas 65.4 × 81.7 cm
The Metropolitan Museum of Art,
H.O. Havemeyer Collection, Bequest
of Mrs H.O. Havemeyer, 1929

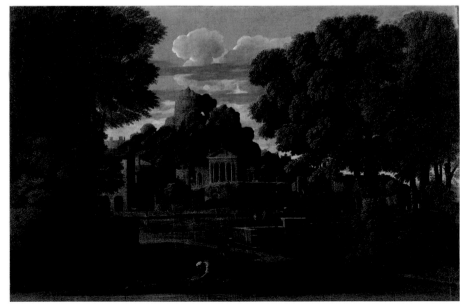

fig.21
Nicolas Poussin
**Landscape with the Ashes of Phocion**
1648
oil on canvas 116.5 × 178.5 cm
The Board of Trustees of the National
Museums and Galleries on Merseyside
(Walker Art Gallery)

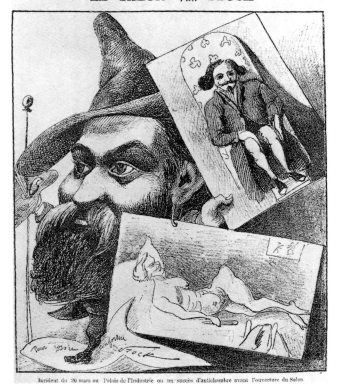

Incident du 20 mars au Palais de l'Industrie ou un succès d'antichambre avant l'ouverture du Salon

## Modern Art

*Nothing but primary force,* id est *temperament, can bring a person to the end he should attain.*

Cézanne to Camoin, 22 February 1903

Cézanne's ideas about the artist's innate sensibility strongly inflect his attempts to forge a style suitable to his identity as a modern artist. In 'A Modern Olympia' (fig.23), for example, he attempts to outdo Manet's 'Olympia' of 1863 in the colourist and Romantic idiom that the poet and critic Charles Baudelaire had identified in his *Romantic Art* of 1867 as the quintessentially 'modern' element of Delacroix's work. Cézanne also affirms his artistic identity in representing himself within the scene as a flamboyant voyeur.

Cézanne's interest in Baudelaire's *Romantic Art* is recorded in a letter to his son of 13 September 1906, and his interest in Baudelaire's writings on Delacroix in a letter of 28 September. Cézanne was also interested in Baudelaire's poetry and Bernard recalls that the artist could recite off by heart his favourite poem, 'The Carcass' from Baudelaire's *The Flowers of Evil* of 1857. Cézanne's interest in the poem went back to the 1860s, when he drew several studies based upon it. One connection between 'The Carcass' and 'A Modern Olympia' lies in the way Cézanne represents his Olympia very sketchily. This closely imitates how the carcass in Baudelaire's poem appeared as 'forms … blurred as in a dream' like 'a slowly shaping sketch forgotten on the canvas'. Cézanne's 'A Modern Olympia' also compares closely, in its treatment of the female body, to the 'Baudelairean' verse that Bernard recalls Cézanne had written on the back of his 'Apotheosis of Delacroix'. In this, he described a 'young woman with rounded buttocks' who is also just 'beautiful meat'. Plainly, the confusion of sadism and eroticism in these Baudelairean representations reveals Cézanne's fantasies about what made a modern artist at their worst.

Cézanne's other sources for his identity as a modern artist are those writers who emphasise the importance of 'feeling' and 'temperament', and the artists that they identify as exemplifying these qualities. For instance, Cézanne echoes Stendhal's emphasis on the necessity of the artist being 'himself', expressing his 'feelings' and having the courage to 'dare' in a comment of 1870, which was published in a caricature by Stock (fig.22) of his submission to the Salon of that year. (This included the Emperaire portrait and a lost Baudelairean nude that Bernard speaks of). According to Stock, Cézanne told him:

I paint how I see and how I feel … and my feelings are very strong. The others, Courbet, Manet, Monet etc., feel and see as I do, but they have no courage. They paint pictures for the Salon. I, however, dare, Mr. Stock, I dare.

fig.22 Caricature of Cézanne from the *Album Stock*, 1870

fig.23 **A Modern Olympia** 1873, oil on canvas 46 × 55 cm
Musée d'Orsay, Paris, don Paul Gachet

fig.24 **Bather and Rocks** *c.*1867–9, oil on canvas 167.5 × 113 cm
The Chrysler Museum of Art, Norfolk, VA, Gift of Walter P. Chrysler, Jr

Cézanne also believed that the artist's innate 'temperament' was the source of his creativity. This idea, and the character that went with it, was parodied in Edmond Duranty's story, 'The Painter Marsabiel' of 1867, where Cézanne can be identified in the eponymous hero through his bald head, 'huge beard' and his repeated and thick Provençal pronunciation of the word *damnbéramminnté* (temperament). Cézanne himself identified 'temperament' with 'creative force' in a letter to Zola of 'Wednesday evening' 1878. However, even early on, his sources show he modelled his style on painters whose work showed 'temperament'. For instance, the Romantic exuberance of 'A Modern Olympia' is lifted from Delacroix, whose 'temperament' and 'passions' had been extensively commentated upon by Baudelaire. And Cézanne's 'Bather and Rocks' (fig.24) is crudely but closely modelled on Courbet, whose individuality and strong character was legendary. Courbet also provided Cézanne with his identity as the *enfant terrible* of the Parisian art world. Although middle class, highly educated and fundamentally reserved, Cézanne's public pose was uncouth and shocking, and he challenged Salon taste with outrageous paintings that had no hope of being accepted. Cézanne's friend Antoine-Fortuné Marion even mentioned in a letter of March 1866: 'Cézanne hopes to be rejected at the exhibition and the painters of his acquaintance are preparing an ovation in his honour.' Towards the end his career, Cézanne was still interested in Courbet, as he told Rivière and Schnerb with respect to a version of the 'Large Bathers': 'I wanted to paint with a full impasto, like Courbet.'

Cézanne's interest in Edouard Manet's 'temperament' can be seen in 'The Artist's Father Reading *L'Evénement*' (fig.25), which utilises the bold contrasts of black and white and the liquid, subtly harmonious greys that Manet had borrowed from Velázquez. Zola identified this style with 'temperament' in the Salon review he published in *L'Evénement* in 1866, and which

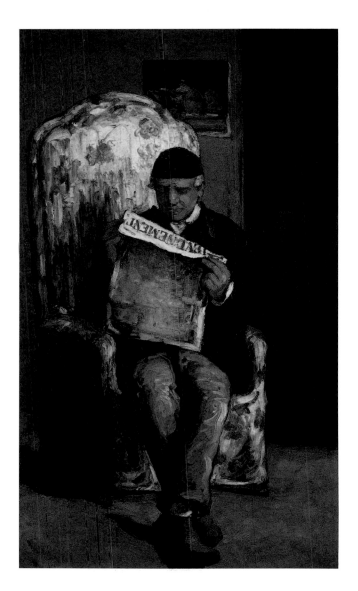

fig.25
**The Artist's Father Reading** *L'Evénement*, 1866
oil on canvas 198.5 × 119.3 cm
National Gallery of Art, Washington.
Collection of Mr and Mrs Paul Mellon

fig.26
**Medea (after Delacroix)** 1880–5
pencil and watercolour on paper 39.5 × 26 cm
Kunsthaus Zurich

he republished in pamphlet form with a dedication to Cézanne. Cézanne's portrait is therefore a testimony to the aesthetic of 'temperament' that he and Zola saw exemplified in Manet, and which in all likelihood they had formulated together as young men.

In his articles, Zola defines a work of art as 'a corner of nature seen through a temperament' and so 'temperament' here is not simply a powerful source of internal feeling, but something that modifies the artist's vision and makes the work expressive as a consequence. To this extent, Zola broadly follows the more moderate ideas on expression to be found in Cézanne's literary sources, such as Stendhal's notion that the artist should 'see nature in his own fashion', and the belief of Manet's teacher, Thomas Couture, that a 'naive, sincere expression' of 'nature' was worth more than 'learned expression'. (Cézanne later told Bernard that he sought 'to apply Couture's ideas'.) In the same vein, the Impressionist Mary Cassatt told friend in a letter of 1894 that Cézanne 'doesn't believe that everyone should see alike'. It may seem a long way from the early temperamental works to late works such as 'Still Life with Blue Pot' (fig.27). However, the seeds of Cézanne's mature style (based on colour harmonies and contrasts) are already present in the painting represented in the background of 'The Artist's Father Reading *L'Evénement*': 'Sugar Bowl, Pears and Blue Cup' (fig.28).

The gradual tendency in Cézanne's development as a modern artist towards a more delicate form of expression can also be seen in his treatment of his sources. For instance, for all the violence of the subject, Cézanne's copy after Delacroix's 'Medea' (fig.26) makes a harmonious and restrained work. Indeed, Bernard recalls that the ageing Cézanne looked to Delacroix precisely for his 'good lessons in harmony'. Baudelaire had praised Delacroix for his manner of being 'coldly determined to find the means of expressing passion in the most visible possible manner' and it is likely Cézanne admired these qualities in his work also. Therefore, it would seem that Cézanne eventually realised that it was not 'temperament' that expressed feeling, but style.

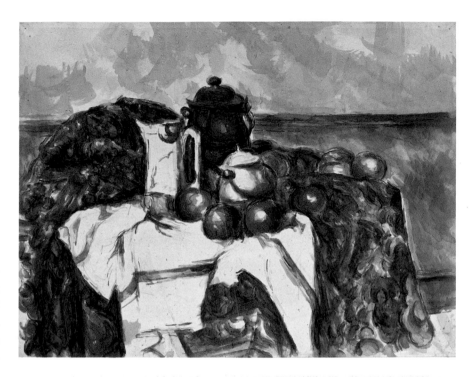

fig.27
**Still Life with Blue Pot**
*1900–6*
watercolour on paper 46 × 61.5 cm
Collection of the J. Paul Getty Museum,
Malibu, California

fig.28
**Suger Bowl, Pears and Blue Cup**
*c.*1866
oil on canvas 30 × 41 cm
Musée Granet, Aix-en-Provence, dépôt
du musée d'Orsay

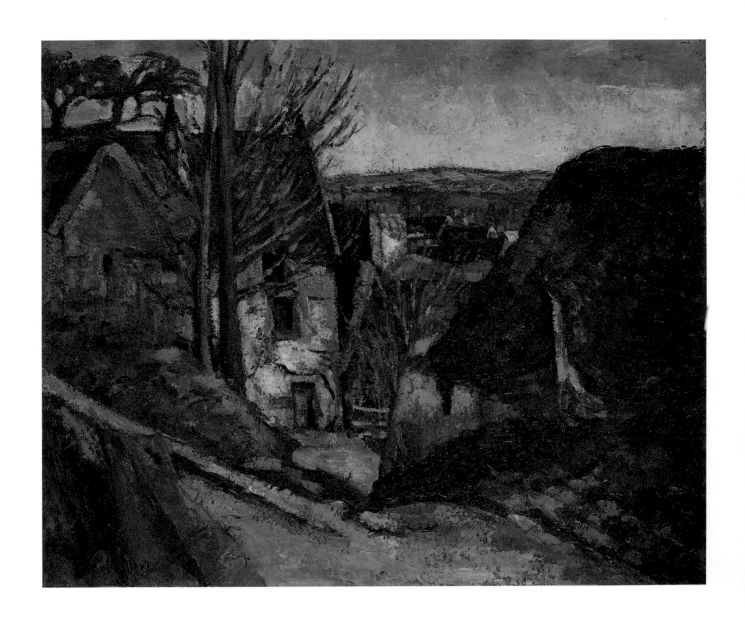

fig.29 **The House of the Hanged Man, in Auvers-sur-Oise** 1873, oil on canvas 55 × 66 cm
Musée d'Orsay, Paris, legs du comte Isaac de Camondo

# Impressionism

*Method is developed in contact with nature ... It consists in seeking the expression of what one feels, and organising feelings into a personal aesthetic.*

Cézanne reported by Larguier

Cézanne's development from a pre-stylistic painter to a mature artist was completed with the informal instruction in Impressionism that he received from Camille Pissarro in Auvers and Pontoise for around a decade from 1872. Following this initiation, Cézanne identified closely with Impressionism. He first appeared in public in 1874 alongside Pissarro, Monet, Renoir and Sisley at the group exhibition that prompted the critic Louis Leroy to coin the disparaging term 'Impressionist'. Here, Cézanne showed 'A Modern Olympia', 'The House of the Hanged Man' (fig.29) and other works. Cézanne spoke of his 'humble personality as an impressionist painter' in a letter to Marius Roux of 1878, and according to Jules Borély, he sometimes referred to his paintings as 'impressions'. Cézanne also made many remarks in praise of Monet and Pissarro, telling Bernard, for instance, that it was their example that freed him from 'the too heavy influence of museums' and reoriented him to 'nature'. And in 1906, at an exhibition of local artists in Aix, Cézanne entered himself in the catalogue as 'a pupil of Pissarro.'

Cézanne's espousal of Impressionism involved a rethink of his beliefs about 'temperament' and 'feeling'. Broadly speaking, he still intended to express the feelings nature provoked in him, as an individual with a particular temperament, but he now believed that the painter ought to submit his temperament to nature. So, for instance, he told Bernard in a letter of 23 October 1905: 'whatever our temperament or form of strength face to face with nature may be ... we must render the image of what we see'. Cézanne's new attitude was consistent with advice to accommodate nature that he

could have found in Stendhal and Baudelaire, but it owed most of all to the impact of the 'humble and colossal' Pissarro.

The concept of *sensation* was also central to Cézanne's new aesthetic. Drawing upon the sense of the term in the vernacular (where it is cognate with the verb 'to feel'), in Stendhal, Couture and Taine, Cézanne used it mean both 'sensation' and 'feeling'. *Sensation* had a similar meaning in the novel, *Manette Salomon*, by Edmond and Jules de Goncourt, which Cézanne admired. The idea was that sensations of nature were charged with feelings, and that in painting his sensations, the artist expressed these feelings as well. Thus, for instance, when Cézanne wrote to Zola of his 'opinion on painting as a means of expressing *sensation*' in a letter of 20 November 1878, he used the word to mean both sensation and the feeling it carried. Cézanne frequently used the word *sensation* in a similar way in conversations and in correspondence with young artists and writers towards the end of his life. He told Aurenche, for instance, in a letter of 25 January 1904: 'the strong *sensation* of nature – and I certainly have that vividly – is the necessary basis for all artistic conception'.

This theory of *sensation* nonetheless links with the idea of 'temperament' in that, in Positivism, it was believed that painting *sensations* could be expressive because they were individual and idiosyncratic, and involved a resonance between the painter and the world. Thus, Bernard recalls that Cézanne told him that 'nature' meant both 'human nature' and 'nature herself'. And even when Cézanne and Pissarro worked side by side – as they did when they painted 'In the Oise Valley' (fig.30) and 'The Quarry of the Chou, Pontoise' (fig.31) – each kept to 'his own *sensation*' (according to a letter of Pissarro's of 22 November 1895). Cézanne's commitment to *sensations* of nature also meant he painted in the open air until late in life (fig.32), even though he was infirm and diabetic.

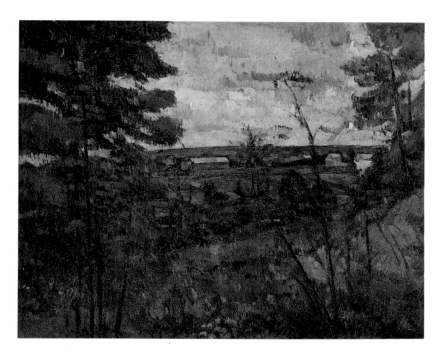

fig.30
**In the Oise Valley**
*c.*1880
oil on canvas 72 × 91 cm
Private Collection

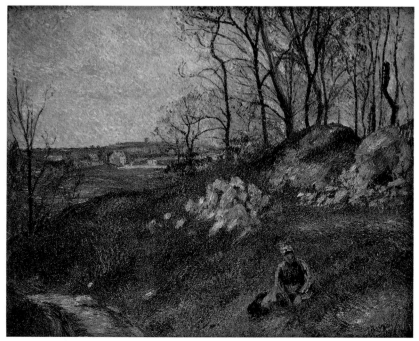

fig.31
Camille Pissarro
**The Quarry of the Chou, Pontoise**
1882
oil on canvas 54 × 65cm
Private Collection, Japan, courtesy of Zen
International Fine Art

The idea that the painting expresses a meaningful resonance between the painter and the world is difficult to explain by reference to Impressionist theory alone. It is possible, however, that Cézanne's ideas on the expressive nature of the landscape were inflected by Baudelaire's notion of *correspondance* as elaborated in his *Salon of 1859*. Put crudely, *correspondance* is what occurs when the landscape takes on a mood or a feeling it does not normally have. For Baudelaire, this was a mysterious phenomenon which could only be explained by the fact that God had organised the world in such a way that visual impressions, sounds and smells corresponded with each other, with the wider cosmic order, and with the soul of the imaginative perceiver. Although a mystical idea, Cézanne may nonetheless have been impressed by it, especially as he was a devout Catholic late in life, and according to Bernard and Borély he believed that God's presence was visible in the landscape.

For Baudelaire, instances of *correspondance* could also include the way that colour relationships remained harmonious as the sun pursued its daily course. And so it is not far-fetched to think that Cézanne's harmonious treatment of the very different light effects corresponding to early morning and mid-afternoon (his preferred times for painting) might have been motivated by his sympathy for Baudelaire's idea. At the very least, it is tempting to think that the balance of colour relationships in different versions of 'Mont Sainte-Victoire' could have been inflected by the following passage from Baudelaire's *Salon of 1846*:

> According as the daystar alters its position, colours change their values, but always respecting their natural sympathies and antipathies, they continue to live in harmony by making reciprocal concessions. Shadows slowly shift, and colours are put to flight before them, or extinguished altogether, according as the light, itself shifting, may wish to bring fresh ones to life. Some colours cast back their reflections upon one another, and by modifying their own

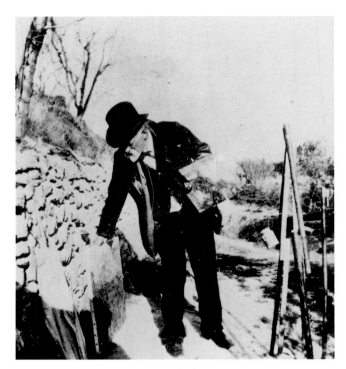

fig.32 **Cézanne at work on the hill of Les Lauves** 1906
Photograph by K-X Roussel

qualities with a glaze of transparent, borrowed qualities, they combine and recombine in an infinite series of melodious marriages which are thus made more easy for them.

In the last analysis, however, it is the painting that is expressive. Thus, neither the notion of the *sensation*, nor the idea that the real landscape 'corresponds' to a feeling for the painter, can properly explain what makes his picture expressive. However, a pointer towards the expressiveness of Cézanne's landscapes can be found in the remark he made to Denis: 'I wanted to make out of Impressionism something solid and durable like the art of museums.' This suggests that it was finally Cézanne's style, and the manner it made his landscape paintings hold together, that made them expressive.

39

# CEZANNE'S MATURE STYLE

## Cézanne's Optic

*Optics, which are developed in us by study, teach us to see.*
Cézanne to Bernard, 23 October 1905

In conversation with Bernard, Cézanne insisted on 'the necessity of an optic and a logic'. He also told him: 'In painting, there are two things, the eye and the mind. Both must help each other; one must work at their mutual development: on the eye through looking at nature, on the mind through the logic of organised sensations, which give the means of expression.' What Cézanne meant was that there were three related dimensions to his practice: his way of seeing, his way of organising what he saw within the picture, and its expressiveness.

As mentioned above, Cézanne's optic is seemingly self-contradictory in that the artist aspired after a naive vision and yet, like Pissarro, he did investigate the nature of vision. This he did rather more than is commonly assumed. For instance, Marion mentions Cézanne's interest in 'science' in letters of 6 September 1867 and April 1868, albeit rather vaguely. But Cézanne's letters of 26 September 1874 and 2 July 1876 (see p.10) show clearly that he had already been consulting Pissarro about technique and vision for some time. (According to Gasquet, Cézanne recalled that Pissarro advised him about 'optical mixture' and had told him: 'never paint with anything but the three primary colours and their derivatives'. However, it is not known when Pissarro gave this advice, if indeed he did.) And in a letter dated 'Friday 1905', Cézanne told Bernard that 'study changes our vision'.

In much the same vein, Cézanne was committed to seeing naively, while he also believed that the artist could never be free from his knowledge of other painters' work. Thus, on the one hand, he urged the artists who visited him to unlearn their established habits of vision and see in a fresh way. So, for instance, he told Bernard, in the letter of 28 August 1905: 'give to image of what we see, forgetting all that has appeared before'. On the other hand, Cézanne regretfully told Borély: 'Today our sight is a little tired, imposed upon by the memory of a thousand images. These museums, museum paintings! And exhibitions! We no longer see nature, we see the paintings.' For all this apparent confusion, Cézanne's interest in optics can make sense if it is seen as his means of unlearning conventional ways of seeing that imposed a ready-made order on nature and the artist.

The net result of Cézanne's optic is that his paintings exhibit features that look like distortions to eyes used to the conventions of perspective. However, the learned character of Cézanne's vision means it is a mistake to take these 'distortions', and his statements about them, at face value – as did some of his earlier interpreters. For example, Rivière and Schnerb tell the following rather contradictory story about their visit to Cézanne in 1905, without seeming to catch the disingenuousness of Cézanne's remarks:

Cézanne energetically declared his horror of the photographic eye, of the mechanically exact drawing taught in the Ecole des Beaux Arts where he said he twice applied without success. This is not to say he denied the superficial

fig.33 **Still Life with Green Melon** 1902–6, watercolour and pencil on paper 31.5 × 47.5 cm

Private Collection

incorrectness of his drawing, the incorrectness which is neither negligence, nor incompetence, but which derives rather from an excessive sincerity … from an excessive distrust of manual dexterity, or a suspicion of every movement where the eye directs the hand without the reason intervening. Thus Cézanne did not make a pretence of being ignorant of the asymmetry of his bottles, or the defective perspective of his plates. Showing one of his watercolours, he corrected a bottle that was not vertical with his fingernail, and he said, as though to excuse himself: 'I am a primitive, I have a lazy eye. I applied to the Ecole on two occasions, but I don't make a harmonious whole: a head interests me and I make it too big.'

One way of explaining such 'errors' of scale in Cézanne's paintings, is to say that he dispensed with the perceptual faculty known as 'constancy'. This normally ensures that objects do not swell or shrink as much as geometry predicts when they approach or recede from the spectator. As Taine explained in *On Intelligence* of 1870, constancy is a function of how our knowledge of the size of an object 'corrects' its image in the eye when this is bigger or smaller than we expect. However he conceived it, it is entirely consistent with Cézanne's aesthetic of innocence that he did away with constancy, as it alters what the artist thought of as the initial and true impression of an object on the eye. For instance, it looks as though the apple in the background of 'Still Life with Plaster Cupid' is too large in comparison with the apples in the foreground. But if Cézanne were trying to see without preconceptions about perspective, it might have looked that big – especially if it were a big Provençal apple.

However, the size of this apple is also a function of the way that Cézanne often compresses the space between foreground and background in his paintings. The immediate cause of this effect is Cézanne's tendency to work from a considerable distance from his subject. From such a position, the space between near and far objects seems less than normal, rather as in a photograph taken with a telephoto lens. This effect is very marked in Cézanne's landscapes. For instance, Cézanne's 'Mont Sainte-Victoire' of c.1889–90 (fig.34) looks quite different from the more conventional version of the same motif that Renoir made around the same time (fig.35). Cézanne hated being watched while painting, and always ensured he was further back from the motif than any artist he worked with. But he might also have adopted his distant viewpoint as a result of reading Jean-Désiré Régnier's *Light and Colour in the Old Masters* of 1865 (which a note in one of his sketchbooks shows he knew). In this, the author argues that the eye focuses only a small section of the visual field, effectively an arc of about 17 or 18 degrees. Thus, to follow Régnier's advice, and ensure the whole motif fell within this small arc of vision, Cézanne had to get very far away from it.

Another oddity in Cézanne's paintings is the peculiar way that they treat the horizontal lines of objects such as tables. These are often discontinuous, and thus appear broken, when they disappear behind an object and re-emerge at another point. For instance, this happens with the table-top in the watercolour, 'Still Life with Green Melon' (fig.33), and with the line of the canvas behind Cupid's head in 'Still Life with Plaster Cupid'. Again though, while this is at odds with our expectations of how things should look, this is how they sometimes do look. The phenomenon was frequently discussed and illustrated in psychological literature – for instance, in Ernst Brücke's essay, *Scientific Principles of the Fine Arts* (fig.36). However, Cézanne might easily have observed the effect for himself, or from looking at Chardin's still lifes. Whatever his source, that Cézanne took account of it is consistent with his attempts to achieve a vision uncorrupted by convention. It should be pointed out, however, that broken horizontals may appear in Cézanne's work because he did not rule in any guidelines for horizontals at the outset of the painting. For instance, no such lines are

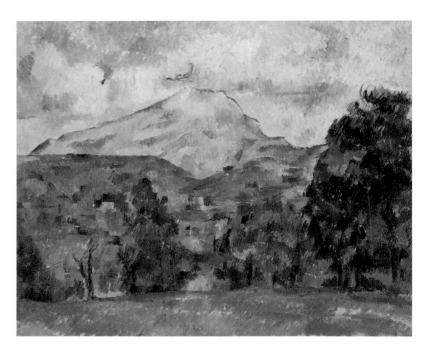

fig.34
**Mont Sainte-Victoire**
1888–90
oil on canvas 65 × 81 cm
The Berggruen Collection
(on loan to the National Gallery, London)

fig.35
Pierre-Auguste Renoir
**Mont Sainte-Victoire** 1889
oil on canvas 53 × 64 cm
Yale University Art Gallery.
The Katharine Ordway Collection

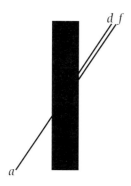

fig.36 Diagram from Ernst Brücke's *Scientific Principles of the Fine Arts* (1878) illustrating how a line (a–d) which is occluded appears to continue along a different path (a–f)

visible in 'Still Life with Green Melon', nor in the very thin and sketchy oil, 'Still Life with Water Jug' (fig.37). Notwithstanding, it is consistent with Cézanne's ambition to paint naively that he did not pre-empt his vision with ready-made schemata.

Cézanne confessed to Bernard that 'sometimes straight lines appear to me to fall', by which he probably meant that verticals appeared to him to slope to the left. As mentioned previously, the glass in 'Bread and Eggs' exhibits this tendency markedly, as do some of the objects in 'Still Life with Green Melon'. It is just conceivable that Cézanne suffered from a kind of astigmatism that made him see this way. However, astigmatism does not explain why Cézanne made his sloping verticals list more markedly each time he went over them. This phenomenon is largely mysterious, but it makes little sense to see it merely as function of Cézanne's naive way of seeing – not least because this would have us believe that both Cézanne and Chardin saw verticals in the same odd way.

Another feature of Cézanne's optic is that objects sometimes look tilted up towards the spectator, with the result that circular shapes become ellipses. Cézanne did use coins to prop up objects in his still lifes according to Louis le Bail, who worked with him in 1898.

However, Cézanne did this only slightly, and only to hold in position round objects like apples or oranges that are difficult to arrange on the flat surface of a table. Therefore, the effect is best explained as a function of how Cézanne recorded the different angles of vision that objects presented to his eyes as he moved them over the motif. The effect looks odd to us, because one-point perspective eliminates it from paintings, and because in photography the camera creates an ideal perspective as its lens does not move.

In many works, Cézanne painted repeated contour lines around the edges of objects. A particularly salient example of this comes in 'Still Life with Green Melon', where there are many blue lines floating outside the edges of the central fruit. It should be noted that these marks are, to some extent, a by-product of Cézanne's working process (see p.61). However, they can also be explained as rough notations which correspond to the peculiar way that Cézanne saw edges. Towards the end of his life, Cézanne confessed to having difficulties with seeing, and with seeing edges particularly. He told Bernard in the letter of October 1905 that the 'sensations of colour' he experienced were 'the reason for the abstractions which do not allow me to cover my canvas entirely nor to pursue the delimitation of objects where their points of contact are fine and delicate'. Cézanne also told the dealer Ambroise Vollard that 'the contour escapes me', and he told Bernard: 'I see [the] planes [of objects] overlapping'. In addition, Bernard recollects that Cézanne frequently spoke of wanting to use a visor like Chardin's to correct his hazy vision, and he specifically mentioned the visor Chardin wore in his 'Self-Portrait with a Visor' (fig.38) in a letter of 27 June 1904 to Bernard. In this, Cézanne remarked:

> You recall the lovely pastel of Chardin armed with a pair of spectacles and a visor making an awning over them. He's a crafty devil, this painter. Have you noticed how, in making a faint plane overlap the bridge of his nose, values become easier for him to see.

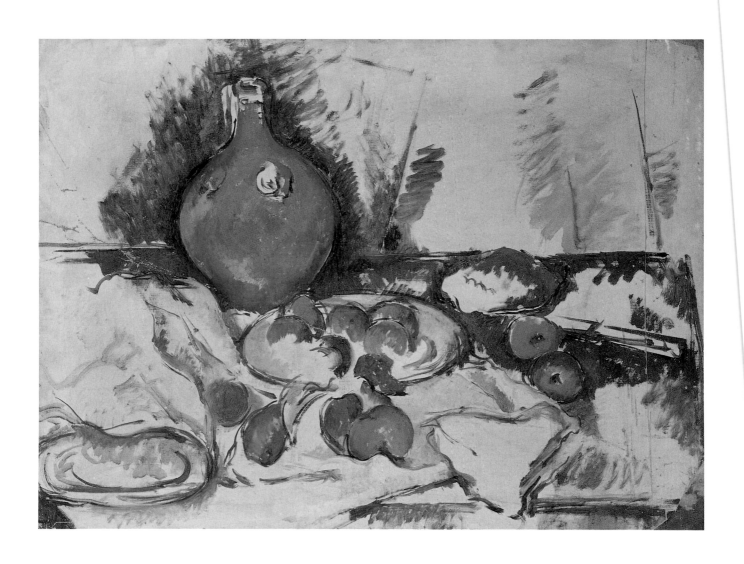

fig.37 **Still Life with Water Jug** *c.*1892–3, oil on canvas 53 × 71.1 cm
Tate Gallery. Bequeathed by Frank C. Stoop 1933

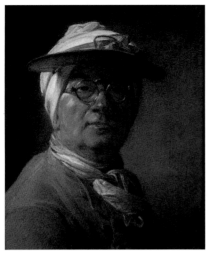

fig.38
Jean-Baptiste-
Siméon Chardin
**Self-Portrait with
a Visor** 1775
oil on canvas
46 × 38 cm
Musée du Louvre,
Paris

It would seem, therefore, that the multiple contours around the objects in Cézanne's paintings record edges as he saw them (even if they also do other things). However, although Cézanne's vision may appear defective to us, this is not entirely how he thought of it. Indeed, at least two of the sources for Cézanne's optic characterised a hazy perception of edges as correct. Régnier argued that the broken contours in some Old Master paintings gave a more natural impression than sharp contours. His argument rested on the observation that the eye cannot simultaneously focus on the edge of an object and the background against which it stands out; and so, the longer we look at an edge, the more it vacillates. Balzac also described seeing hazy edges and using multiple contours as a virtue through the character of the painter, Frenhofer, in his short story *The Unknown Masterpiece*. Cézanne's certainly identified with Frenhofer, as he listed him as the literary character he found most sympathetic, and both Bernard and Gasquet confirm Cézanne's interest in him. Specifically, Frenhofer denied that sharp edges are visible at the extremities of figures (or other objects). As he explains, with reference to the painting that gives Balzac's story its title:

I have not, like a multitude of ignorant fools who imagine that they draw correctly because they make a sharp, smooth stroke, marked the outlines of my figure with absolute exactness … for the human body is not bounded by lines … Nature provides a succession of rounded outlines which run into one another. Strictly speaking, drawing does not exist!

There is perhaps another explanation in Cézanne's optic for the multiple and ill-defined contours around the edges of objects in his works. This is that Cézanne was attempting to overcome one the main deficiencies in painting's ability to render reality convincingly: namely, its inability to capture the three-dimensionality of stereoscopic vision. Hermann von Helmholtz, a major figure in the science of optics, had mentioned this problem in his essay 'Optics and Painting' which appeared in French in 1878, in a volume together with Brücke's essay. Whether or not Cézanne knew this text, it seems that he tackled the problem of steroscopic vision in a drawing after Duquesnoy's 'Cupid' (e.g. fig.39), where he observes the cast from slightly to the right, and slightly to the left, of a normal one-point perspective. In this drawing and the related 'Still Life with Plaster Cupid', the hazy lines marking the cast's edge also convey the ill-defined character that an artist's stereoscopic vision can take on when he observes it at work.

Many of the oddities that Cézanne's optic produced nonetheless helped him achieve expressive effects. His binocular vision, and his observation of vacillating edges and 'tilting', have the effect that objects in his paintings gain a peculiar tactile quality. Cézanne's use of a distant viewpoint, and his observation of discontinuous horizontals and sloping verticals, make the painting hold together tightly. All in all then, Cézanne's optic led him to make paintings which express feelings to do with touch.

fig.39 **Cupid** *c.*1890, pencil on paper 49.7 × 32.2 cm
Trustees of the British Museum

## Hippolyte Taine and the Sensation

*See like a man who has just been born.*

Cézanne reported by Borély

Not only did Cézanne subscribe generally to the idea of naive vision, but it is likely that he subscribed specifically to the ideas in Hippolyte Taine's *On Intelligence* about the 'primitive' character of the sensation. It is not recorded that Cézanne knew Taine's book at first hand, but he might easily have assimilated its main ideas through contact with Monet or Zola, who both knew Taine's work.

Cézanne's statements certainly echo Taine's ideas that a naive vision, or 'pure retinal sensation', consisted only of 'variously coloured patches', and they also recall Taine's belief that the artist could work simply by representing 'patches of colour'. For instance, Rivière and Schnerb recall that Cézanne used the term 'sensation of colour' to describe what he saw. Bernard recalls Cézanne told him: 'To paint is to register one's sensations of colour'. Like Pissarro, who said he saw only 'stains' of colour, Cézanne reputedly told Joachim Gasquet: 'I see. In stains.' And Bernard told his mother in a letter of 5 February 1904 that Cézanne 'sees in little tones'. Moreover, Bernard recalls that Cézanne painted 'without preoccupying himself with objects themselves' – meaning that he painted only the colour patches composing raw sensation. In all likelihood, the foundation of these statements was Taine's idea that normal vision is a construct which the mind builds up by using memories of other experiences, notably touch, to 'read' the colour patches on the retina as objects in space. 'Pure' sensation, by contrast, was unaffected by interpretation. Cézanne certainly seems to have subscribed to this idea inasmuch as he told Bernard that his aim was to 'read nature', but 'see it under the veil of its interpretation as patches of colour'.

However, Cézanne's indebtedness to Taine's ideas emerges most clearly in his wish to 'see like man who has just been born', and in the desire he expressed in a letter of 3 June 1899 to Henri Gasquet to seek 'expression of the confused sensations that we bring with us when we are born'. These remarks recall Taine's idea that a person experiences pure sensation when he or she first acquires vision. This normally happens shortly after birth, but it can also occur when a blind person recovers sight. Very probably, Cézanne was experimenting with this kind of innocent vision in 'Madame Cézanne in a Red Armchair' (fig.40), as everything in it is analysed into the colour patches of raw sensation. In this work, it appears that Cézanne also tried to represent how, according to Taine, colours seem to such a person 'to touch his eyes'. (His argument is that the newly sighted situates his or her sensation in the sense organ where it arises.) Arguably at least, Cézanne does this in the way he represents the colour patches corresponding to the crosses in the wallpaper as if they were floating off the wall towards the spectator.

Cézanne's use of colour patches can also be explained by reference to Taine's argument that the normal adult came to 'localise' sensations of colour on the surface of objects by co-ordinating these, through repeated experience, with sensations of reaching out or walking over to an object, and touching it. Taine suggested that people subsequently learned to localise sensations of colour by correlating them with the minute sensations in the muscles of the eye responsible for focusing; but crucially, he argued that the sheer efficiency of this last process meant that adults eventually disassociated sensations of colour from the 'original' sensations of touch corresponding to them, so that they became mere, abstract 'signs' which needed 'contemplation' to 'revive', or regain sensory fullness. Following this logic, Cézanne leaves it up to the spectator to re-invest his patches of colour with tactile and spatial properties for

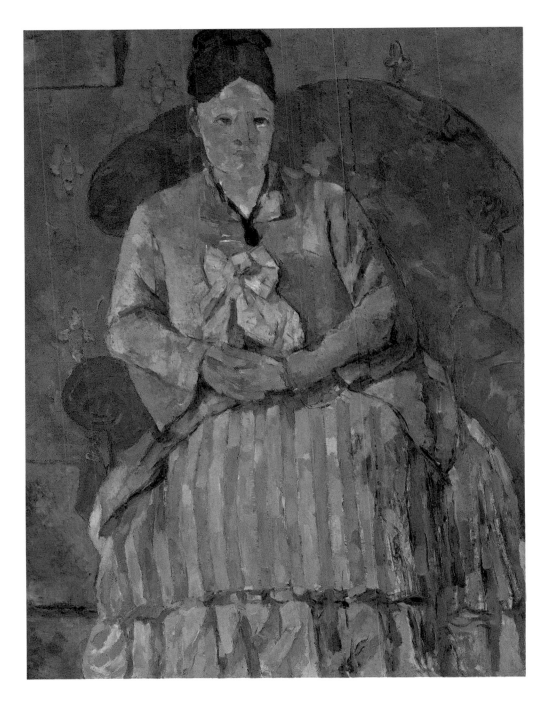

fig.40 **Madame Cézanne in a Red Armchair** 1877, oil on canvas 72.5 × 56 cm

Museum of Fine Arts, Boston. Bequest of Robert Treat Paine, 2nd

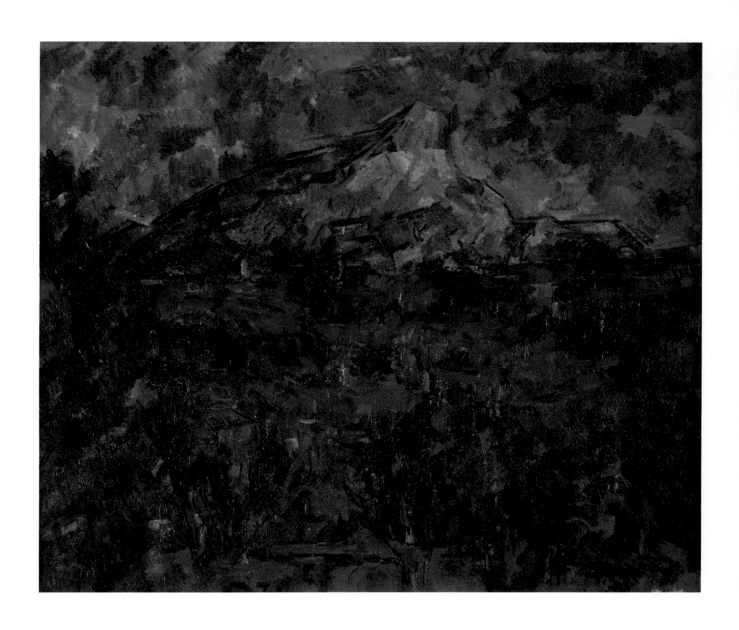

41 **Mont Sainte-Victoire** 1904–5, oil on canvas 60 × 73 cm
Pushkin Museum of Fine Arts, Moscow

his or her self. In particular, Taine's ideas seem likely to have affected the very late 'Mont Sainte-Victoire' paintings (e.g. fig.41), which are almost all colour patches, and a large part of whose interest lies in how they invite the spectator to interpret them into meaningful spatial relations.

Like much contemporary science, Taine's theories have to be regarded nowadays as simplistic. Thus it would seem that Taine's ideas, like other elements of Cézanne's optic, were less valuable for what they told the artist about perception, than for the expressive effects they allowed him to put into the painting under the sanction of science.

## The Logic of Organised Sensations

*To read nature is to see it under the veil of its interpretation as coloured patches following one another according to a law of harmony. These colours are thus distinguished by modulations. To paint is to register one's sensations of colour.*

Cézanne reported by Bernard

Put very schematically, the basis of Cézanne's mature technique was the idea that the painter only needed colour to represent his *sensation*. Colour, in other words, was to do all the jobs normally associated with representing the artist's vision. However, turning this idea into practice prove rather more complex than this simple formulation suggests.

In the first place, Cézanne was acutely aware of how he could not capture natural luminosity on canvas. He told Denis, for example, that 'I wished to copy nature, but I did not succeed' and: 'Light is not something that can be reproduced, it must be represented by something else, by colours'. Cézanne's realisation might have been prompted by remarks of Stendhal's or Régnier's on the painter's inability to copy nature. But the wording of Cézanne's remarks strongly echoes Helmholtz's discussion of the subject in 'Optics and Painting'. For instance, according to Larguier, Cézanne said: 'To paint is not to copy the objective world slavishly; it's to seize a harmony between numerous relationships, to transpose them into an appropriate scale, and develop them according to a new and original logic.' And he told Borély about nature: 'there is a dull brilliance in it which I cannot equal on my canvas; but I excite this impression by another which corresponds to it.' Helmholtz wrote: 'What the artist must give is not simple copy of the object, but a translation of its impression into another scale of sensation.'

Helmholtz's essay certainly gives a lucid explanation of the painter's problem. He points out how the light of the open air is often very much brighter than the in-

door light reflected from the painting surface. And he also points out how the eye can detect a much wider range of values in nature than the painter's media can reflect. For both reasons, therefore, a painting may never reproduce the light that the eye can see in the sunlit landscape. And so, in a work such as 'The Great Pine' (fig.42), the colours of nature are only coded, and not copied.

In the attempt to overcome this problem, Cézanne used many juxtaposed complementaries and near-complementaries to simulate the power of the sensation in which the painting originated. Moreover, in combining these contrasts within an overall harmony of colour in the painting, Cézanne was attempting to follow the principle of harmony that he (and Régnier and Baudelaire) believed to be responsible for the organisation of colour in nature. As Bernard recalls, Cézanne actually saw nature as harmonious, and according to Larguier, he believed that there was an atmospheric 'envelope' in nature into which 'oppositions' of colour decomposed. This envelope, Cézanne also stated: 'constitutes the envelope of the painting in contributing to its synthesis and its general harmony.' Cézanne put these ideas about harmony together with his ideas about coding in the cryptic remark he made to Joachim Gasquet in a letter of 26 September 1897: 'Art is a harmony parallel to nature.'

Nature's harmony aside, Cézanne had another reason for meticulously observing the harmony of the painting – the fact that colour relationships were, ideally, his only means for representing the depth in nature. Cézanne told Rivière and Schnerb that line did not exist in nature, and that colour alone gave the idea of form and shape. And according to Larguier, Cézanne stated that 'Line and modelling do not exist'. Larguier also published a statement by Cézanne which recalls Baudelaire's belief that line and colour were 'abstractions': 'Pure drawing is an abstraction. Drawing and colour are not distinct, everything in nature being coloured.' Therefore, Cézanne banished line from his art in principle – even if he was often unable to do without it in practice. (Thus, in a letter of 23 October 1905, he warns Bernard against the Cloisonnist style because it 'circumscribes contours with a black line, a fault which must be fought at all costs'.)

Cézanne made several statements which help explain how he saw colour as a means of drawing. He told Bernard that 'the secret of drawing and modelling' was 'contrasts and relationships of colours'. He told Denis: 'Colour has to express all the breaks in depth.' And he told Bernard:

> Modelling results from the perfect relationship of colours. When they are harmoniously juxtaposed and they are all in place, the painting models itself.

An explanation of how Cézanne achieved modelling through colour must begin with the fact that he organised colours in a harmonious play of warm and cool. Cézanne alluded to this technique in a statement to Rivière and Schnerb that he 'conceived modelling as a succession of tints running from warm to cool'. Put crudely, the logic behind this technique is that even when they lie on the same surface, warm colours appear to advance and cool colours to recede. Thus, they can be used to produce effects of relief and recession. Cézanne's technique of drawing with colour can be seen in the still life, 'Apples and Oranges' (figs.43–4). Obviously enough, in this work, the modelling achieved by warm and cool hues is not an effect of colours in isolation. Rather, colours react strongly with neighbouring colours, and they also react with all the other colours in the painting. In so doing, they modify each others' hue, intensity and saturation, and they also affect each others' apparent size and position in depth, or 'drawing'. Thus, no one patch of colour models form on its own; it only contributes to the effect produced by the relationships of the painting as a whole.

The global interactions of colour in the painting

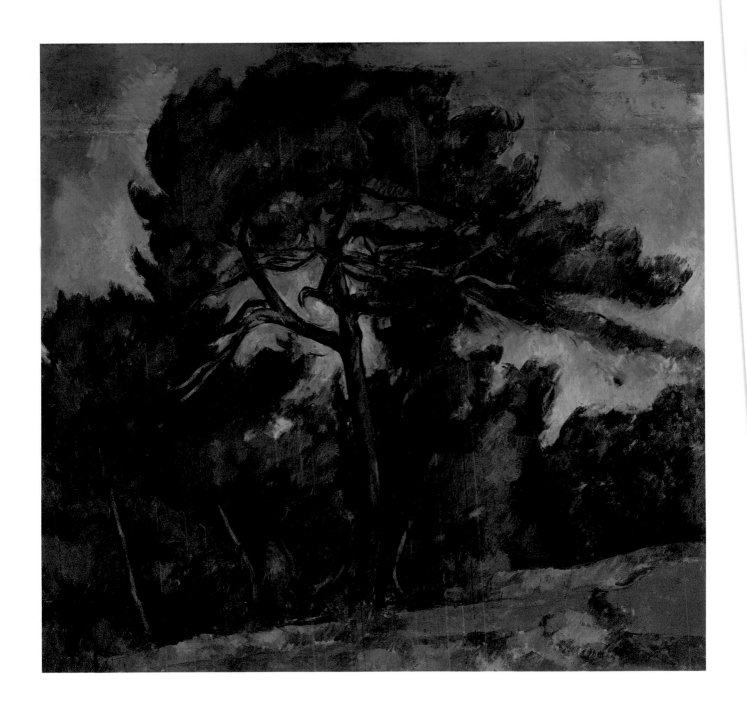

fig.42 **The Great Pine** *c.*1889, oil on canvas 84 × 92 cm
Museu de Arte de São Paulo, Assis Chateaubriand, São Paulo, Brasil

fig.44 **Apples and Oranges** *c.*1899
oil on canvas 74 × 93 cm
(fig.43 detail on left)
Musée d'Orsay, Paris, legs du Comte Isaac de Camondo

fig.45
**Pyramid of Skulls**  1898–1900
oil on canvas 37 × 45.5 cm, Private Collection

meant that Cézanne had to tune his colours in order to ensure that the drawing they produced was right. This technique is known as modulation – Cézanne told Bernard, for instance, that 'one should not say model; one should say modulate.' (He used this word to express how he conceived the component colours of the painting rather as notes which functioned within the harmony, or the key, of the whole.) Cézanne often modulated or adjusted the local colour of objects in order to make this fit with the global harmony of the painting. This sometimes results in objects looking as though their colour and shape is wrong when they are seen in isolation. However, when the same section of the painting is seen in the context of the whole, it will look right.

## The Build-Up of the Painting

*He never made a mark that was not long considered.*

<div align="right">Cézanne reported by Bernard</div>

For good reason, Cézanne's attention to the harmony and drawing of the painting was almost obsessive. For instance, Bernard recalls that Cézanne constantly modified a still life closely related to 'Pyramid of Skulls' (fig.45) so that 'this painting changed colour and form almost every day'. Cézanne did this, he observes, even though at any point in its progress 'one might ... easily have taken it off the easel as a finished work'. Cézanne's problem was that each touch of colour he added to the picture affected its harmony and thus altered its drawing. So every time he applied a colour, he needed to ensure it harmonised with the rest of the work. If he chose a colour that did not quite fit, he would adjust it by mixing or glazing. Often he would adopt the more laborious alternative and change parts of the painting that he had already established. Given the difficulties of such procedures, it is hardly a surprise that many of Cézanne's mature paintings remained unfinished.

The most poignant account of Cézanne's problems comes in Vollard's recollection of Cézanne painting his portrait (fig.46). If Vollard is to be believed, it was the only the want of two tiny touches that prevented Cézanne from finishing this work:

> For someone who has not seen him paint, it is difficult to imagine the extent to which, some days, his progress was slow and painful. In my portrait, there are two little spots on the hand where the canvas is not covered. I pointed then out to Cézanne. He replied: '... I may be able to find the right colour with which to fill in those blank patches. But understand a little, Monsieur Vollard, if I put something there at random, I would be forced to begin my painting again, starting from that point.

Although Bernard suggests in the letter to his mother of 1904 that Cézanne worked, like Ingres, by 'finishing

fig.46 **Portrait of Ambroise Vollard** *c.*1899, oil on canvas 100 × 81 cm
Musée du Petit Palais, Paris

fig.47 **Gardanne** 1885–6, oil on canvas 92 × 74.5 cm
The Brooklyn Museum, New York, Ella C. Woodward
and A.T. White Memorial Funds

details before bringing on the whole', this is almost certainly a misconstruction of the place of blank patches in Cézanne's paintings. As Vollard's account shows, these have an active role in the global harmony of the painting, and cannot be replaced unless with an appropriate colour. Indeed, it would have made little sense for Cézanne to proceed by finishing isolated details. Unless he took great care to match any colours he added subsequently with these details, he would not have been able to add to the painting without harming

them. Unsurprisingly, Cézanne abandoned any semblance of this procedure not long after the unsuccessful paintings of Gardanne (fig.47), which exhibit many unpainted areas alongside relatively finished details.

In his late work, Cézanne normally brought along the whole picture at once in order to keep it harmonious in its entirety as it developed. The critic Gustave Geffroy recounts that Cézanne did this very tentatively, by 'accumulating … thin films of colour'. And Bernard describes this method as an 'attentive and patient march' in which 'every part is treated at once, and accompanies the other'. No surprise then that Cézanne told Gasquet in a letter of 5 September 1903 that he needed another six months to complete the canvas he was working on. Bernard even recalls (in the letter to his mother) that by 1904, Cézanne had already spent ten years working on one version of 'The Large Bathers'.

In the effort to obviate the difficulties his procedure entailed, Cézanne tried to develop ways of anticipating the progress of the painting. One of these was to sketch out its colour harmonies thinly at the outset. These 'incipient scales', as Bernard called them, were normally submerged beneath the subsequent layers of the painting, but occasionally Cézanne left a painting at this stage of incompletion. A good example is 'Mont Sainte-Victoire Seen from Bibémus' (fig.48). Compared with another painting of a nearly identical motif (fig.49), the sketch is relatively neutral in its colour scheme. This is because Cézanne only developed the painting's more intense colour harmonies in its later stages. As he told Bernard, it was best 'to start lightly with almost neutral tones' and to 'proceed by continually raising the scale of colours and drawing them together more'. Thus he would end up with rich colour relationships that did the job of drawing successfully. Or, as he told Bernard: 'The more the colour is harmonious, the more the drawing is precise. When colour is at its richest, form is at its fullest.'

fig.48

**Mont Sainte-Victoire Seen from Bibémus**

*c.*1890–5

oil on canvas 55 × 65.4 cm

National Gallery of Scotland

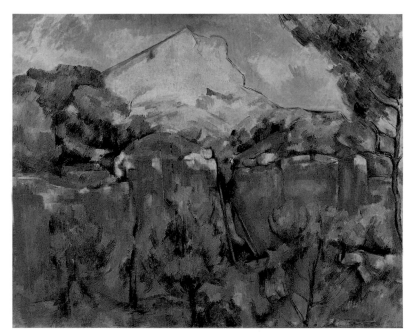

fig.49

**Mont Sainte-Victoire Seen from Bibémus**

*c.*1897

oil on canvas 63.8 × 80 cm

The Baltimore Museum of Art: The Cone Collection,

formed by Dr Claribal Cone and Miss Etta Cone of

Baltimore, Maryland

fig.50 **The Kitchen Table** 1888–90, oil on canvas 65 × 81 cm
Musée d'Orsay, Paris, legs Auguste Pellerin

According to Bernard, Cézanne also anticipated the development of the painting by arranging 'scales ready-made on the palette' which he then 'proceeded by applying'. While this contention cannot be tested against the evidence of the relatively opaque oils, something of Cézanne's procedure can be seen in the more transparent watercolours. In these, however, Bernard recalls that Cézanne used another 'highly individual' technique of controlling the progress of the painting – although this, too, seems based on harmony and contrast. The technique in question can be seen in works such as 'Mont Sainte-Victoire' (fig.10), which closely match Bernard's account of how Cézanne

> started with the shadow and with a patch of colour which he covered with another more extensive patch, until the stage where all these touches, forming screens, modelled the object while colouring it. I understood immediately that there was a law of harmony which guided his labours and that all these modulations had a direction determined in advance, in his reason. All in all, he proceeded as the tapestry makers of old must have done – making related colours follow upon one another until they encountered their complementaries.

It is important to realise that the global harmony of colours in a painting by Cézanne is so delicate that it can easily be upset by the frame or the wall around it. Thus, Cézanne was careful to paint the walls of his last studio a light grey, thereby ensuring that this neutral hue would not interfere with the colour harmonies in his paintings. Similarly, he did not frame his own paintings often – for instance, none of the canvases represented in 'Still Life with Plaster Cupid' is framed. When a work had to be framed when it was sold or exhibited, Cézanne liked the frame not to be too obtrusive, and he preferred natural wood tones or dull gold over the emphatic gilt favoured by dealers and museum curators.

## Line

*There is no line, there is no modelling, there are only contrasts. These contrasts are … the sensation of colour.*

Cézanne reported by Bernard

Despite Cézanne's commitment to seeing and painting only in colour patches, lines nonetheless appear in many of his works. As mentioned above, Cézanne's optic only provides a partial solution to this phenomenon, and it is necessary to look at the artist's working methods to explain it.

A valuable account of Cézanne's use of line comes in Rivière's and Schnerb's memoir, which states that, for Cézanne, it was only 'a means of capturing the whole of a form more easily by contour before modelling it with colour'. By this account, Cézanne used line in the early stage of the painting purely as an expedient, with the intention of replacing it later in the painting's development with colour relationships. An excellent example of Cézanne's use of line in the lay-in of the painting is the sketch 'Still Life with Water Jug' (fig.37). In this, the process of applying colour has only just begun, and rough contours delineating the placement of objects are still clearly visible.

This account does not explain the presence of lines in more finished works such as 'Apples and Oranges', where contours are clearly visible around the edges of some of the apples, and at the left edge of the plate. One explanation of these lines is that they are quick and easy, and sometimes indispensable, aids in keeping the drawing that colour achieves on the right track. They are needed because objects in the painting will contract or swell, and advance and recede, as the colour relationships modelling them are altered in accordance with the developing harmony of the painting. However, in works such as 'The Kitchen Table' (figs.50–1), Cézanne's progress is so complex that there are many stages where line comes in and out of the picture. For

instance, Cézanne all but eliminated line from the left side of the large pear at the right of the painting, and colour relationships do the job of drawing here. On the lower right side of the same pear, the original contour line has become all but sunken beneath the thick accretions of colour on either side of it which model the fruit and the cloth behind it on their own. However, the ghost of the original contour is still visible towards the top of the fruit. There is also a thick line under the bottom edge of the pear which seems partly a contour, and partly to denote a shadow. And on the top right of the pear there is a contour line floating outside the body of the fruit. Presumably this a late addition designed to hold it in place. And it shows how, sometimes, Cézanne simply could not get the results he wanted with colour alone.

An account of Cézanne's optic and logic goes a long way towards explaining his paintings, but in the final analysis there remain features of his work that neither explains. This is because the satisfying effect of the painting on the artist in his role as spectator often has the last word in its appearance – whatever the artist as agent told himself he was doing.

## Cézanne and Touch

*Understand that I bring the whole of my painting along, together ... my canvas joins hands!*

Cézanne reported by Joachim Gasquet

According to a rather unreliable account that Bernard published in 1921, Cézanne told him that the painter 'gives a new interest to ... nature' and 'renders as a painter that which has not yet been painted'. Bernard's account is nonetheless apt insofar as Cézanne's paintings do transform nature, either through determining their own progress, or through affecting the way the artist sees nature. But almost always, when Cézanne's paintings do this they express feelings connected with touching and being touched – which are inextricably related in that one always involves the other.

Cézanne's paintings often express such feelings through spatial ambiguities that bring parts of the depicted scene within the reach of the spectator. For instance, the compression of foreground and background in the landscapes does this, as does the floating wallpaper pattern in 'Madame Cézanne in a Red Armchair'. In 'Apples and Biscuits' (fig.52), both effects come together, with the result that the floral motif in the wallpaper becomes almost tangible. The effect is reinforced by the emphatic quality of the artist's brushstroke. This allows the spectator to recreate how the artist, in touching the depicted object in the act of painting it, imaginatively touches the real object itself, or brings it within reach. This effect is further reinforced by the tightly knit global harmony of the painting, which imparts a uniform and tactile character to all the objects it contains. Together, these devices add up to a strange kind of representational ambiguity that makes the wallpaper pattern look almost as real and palpable as the still life in front of it.

As Shiff points out, Cézanne's most dramatic experiments with the effects of ambiguously represented ob-

fig.51 **The Kitchen Table** 1888–90 (detail)

63

fig.52 **Apples and Biscuits** *c.*1880, oil on canvas 46 × 55 cm
Musée national de l'Orangerie, Collection de Jean Walter et Paul Guillaume

fig.53 **Jug and Fruit** 1893–4, oil on canvas 43.2 × 62.8 cm
The Berggruen Collection (on loan to the National Gallery, London)

jects occur in 'Still Life with Plaster Cupid'. In this, the real blue tablecloth under Cupid merges with a painted version of the same cloth contained in the picture behind the cast: 'Still Life with Peppermint Bottle' (fig.55). The Cupid itself takes on an ambiguous identity halfway between painting and sculpture, in that it is set against a canvas behind it, and almost becomes part of this picture. And Cézanne actually includes a picture of a sculpture in the background of the painting, where a study of the 'Flayed Man' leans against the wall. The cumulative effect of these ambiguities is to make everything in the painting appear cut free from the real space of the studio, and instead, seem near the spectator, and tangible.

Some light on why Cézanne was so concerned with touch is shed by an account Bernard gives of how the artist reacted to being touched himself. In this, Bernard describes how he went to help Cézanne to his feet after he had tripped and fallen over. A harmless enough action, we might think, but he continues:

> Scarcely had I put my hand on him to do him this courtesy, that he flew into a rage, swore at and abused me, then he ran off, from time to time throwing a fearful glance in my direction as if I had tried to kill him … He went back inside his house, leaving all the doors open as though to invite me in … Once I was back there … he jumped up, his eyes bulging … Then he swore terribly, frightening me by his terrifying demeanour, and stammered: 'nobody may touch me … Do not get your hooks into me. Never! Never!'

In all probability, Cézanne's anxiety was some residue of the inhibited and frustrated sexuality that he had suffered since youth, and his temper was certainly not improved by his diabetes. Whatever its origin, Cézanne's reserve about touching and being touched enters his pictures of the human figure. In these, it is as if he were projecting his feelings about his own body into the way he handles the bodies he represents. For instance, in 'The Large Bathers' (frontispiece and

fig.55 **Still Life with Peppermint Bottle** *c.*1894
oil on canvas, 65.9 × 82.1 cm
Board of Trustees, National Gallery of Art, Washington.
Chester Dale Collection

fig.54), many of the figures are immune from intrusion: they are shielded by multiple contour lines, and not one of them has a mouth. Even their eyes are obscure. Cézanne also worked through feelings about touch in paintings that do not represent bodies directly. In some still lifes, 'Jug and Fruit' (fig.53) for example, it is hard to resist the temptation to see the fruits as metaphorical bodies – and bodies of different sexes at that. There is even some evidence that Cézanne saw the objects in his still lifes this way. Cézanne told Ambroise Vollard to 'sit like an apple' for his portrait, and it only reverses the metaphor to say he wanted his apples to sit like people. And if Joachim Gasquet is to be trusted, Cézanne did exactly that when he said in respect of his still lifes:

fig.54 **The Large Bathers** 1894–1905 (detail)

fig.56 **The Château de Médon** *c.*1880, oil on canvas 59 × 72 cm
Glasgow Museums. The Burrell Collection

One has to know how to grasp them, to cajole them, these fellows … These glasses, these plates, they talk to each other. Interminable confidences … Flowers, I have given up. They fade immediately. Fruits are more faithful. They like to have their portraits painted. They sit there as if to beg pardon for loosing their colour.

Cézanne's treatment of these 'bodies' can be connected to his feelings about his own body, in that the more resolved parts of the painting are those which treat the individual fruits in isolation. In the bottom corner, where one fruit impinges on another – as Bernard did on Cézanne – the drawing of the painting becomes distinctly uncomfortable.

In the landscape paintings, it is not normally the scene depicted, but the techniques of depiction, that metaphorise Cézanne's feelings about touch. And these effects also make some sense of how they take on moods, or induce feelings in the spectator. In other words, the expressive effects of Cézanne's landscapes suggest that *correspondance* is not simply an effect of the natural world, but is also an effect of the painting itself. In 'Château de Médan' (fig.56), for instance, the brushmarks are aligned with respect to one another, and to the framing edge, and thus express a pleasant feeling of mutual respect. And in nearly all the late works, the colours responsible for drawing react intimately, but respectfully, with one another in forming the tightly knit harmony of the whole painting. According to Joachim Gasquet, Cézanne specifically attributed such qualities to the touches composing his landscapes. One day, while painting, Cézanne told him:

> 'I hold my motif …' (He joined his hands.) 'A motif, do you see, it's this …' (He made the gesture again, opened his hands, his ten fingers spread out, and brought them together slowly, very slowly. Then he joined them, gripped them, knitted them, making one penetrate into the other.) 'That's what one must achieve.'

Of course, Cézanne's mature style has similar expressive effects across the different categories of his work. And in the portraits, this is sometimes signalled by the sitter's knitted, or folded, hands. However, it is crucial to observe that the painting is both like, and unlike the painter's own body. It is sufficiently like his body for him to be able to project his own feelings into it; but it is unlike his body enough to transform these feelings. It is this that explains how nothing could be further from Cézanne's usual attitude towards his own body than the 'Portrait of Victor Chocquet' (fig.2), in which the sitter is as harmoniously integrated with his surroundings as his hands are with one another.

fig.57 **Three Bathers** 1879–82, oil on canvas 52 × 55 cm
Musée du Petit Palais, Paris

# CEZANNE'S LEGACY

*Cézanne! It was the same with all of us – he was like our father. It was he who nurtured us ...*

Brassaï, *Conversations avec Picasso*, 1964

The list of artists who explicitly claim to have inherited Cézanne's example is impressive. It includes Maurice Denis, Paul Gauguin, Edouard Vuillard, Pierre Bonnard, Fernand Léger, Jean Metzinger, Amedé Ozenfant, Juan Gris, and perhaps more surprisingly, Wassily Kandinsky, Max Beckmann, El Lissitsky, Jackson Pollock, Hans Hofmann and Joseph Kosuth. Indeed, in the early part of this century, Cézanne was a fad or even a fetish to many a young artist. Or as Henri Matisse told Jacques Guenne in 1925: 'Cézanne, you see, is a sort of God of painting. Dangerous, his influence? So what? Too bad for those without the strength to survive it.'

While Matisse's comment is a useful testimony to Cézanne's importance, his use of the word 'influence' suggests that Cézanne's work exerted some mysterious force upon later artists (rather like the planets were supposed to exert their influence on human destiny). However, Cézanne had no 'influence' of this kind upon the succeeding generation. Rather his work provides examples, or paradigms, of techniques and effects that they could use to their own purposes. Thus although Cézanne's work undoubtedly exemplified the qualities it did in a unique way, it became important to younger artists for a number of other reasons as well. For instance, Cézanne's art both answered questions in the contemporary debate about the character and aims art should have, and also suited the social need for a domain of aesthetic value independent of, and alternative to, a daily life defined and constricted by work.

Thus, Cézanne's art had far-reaching impact as a demonstration of art's autonomy of identity and effect. That is, it seemed to show that art could no longer attempt to copy what it represented, and that instead it must accept and declare its nature as art, and rely upon producing the effects proper to itself. So it was that early twentieth-century artists largely took Cézanne's work as an example of how art should be produced for art's sake, and on the back of this, they saw his isolation and esoteric practice as a model for the a-social existence of the modern artist. By the same token, although Cézanne's example shows that art can allow the spectator access to feelings and values normally suppressed in daily life and the ideologies that govern it, this aspect of Cézanne's work was largely ignored and misrepresented. All in all, therefore, instead of being taken as an example of how art can provide an alternative to life, Cézanne's work became institutionalised as the paradigm of the self-referential, aetheticised, Modernist art. Of course, this is not something that artists achieved on their own. Indeed, the hermatic sealing of modern art within its own social and cognitive space has only been achieved by society at large producing official, Modernist culture in this way.

For all this, there were artists who responded sensitively, and appropriately, to Cézanne's example. For instance, Picasso picked up Cézanne's ambition to make art 'a harmony parallel to nature', and made it his aim to demonstrate how: 'Nature and art, being two different things, cannot be the same thing.' Picasso, Braque, and Matisse also responded sympathetically to Cézanne's researches into space and tactility. And, via

71

fig.58 Henri Matisse, **Dance (II)** 1910, oil on canvas 260 × 391 cm
The Hermitage Museum, St Petersburg

these artists' work, Cézanne's example permeated twentieth-century art in many of its other manifestations: the work of Mark Rothko and Piet Mondrian, for example, would be inconceivable without it.

Matisse was particularly sensitive to the techniques and effects Cézanne had developed in his 'Three Bathers' (fig.57), a painting which Matisse owned and studied for thirty-seven years. The same work also stands behind Picasso's early Cubist pictures, and thus indirectly informs Braque's paintings. In other words, it provided all these painters with features of their mature style, and illustrates conveniently how Cézanne was a father to modern art in a metaphorical, but nonetheless substantial sense.

In 'Dance' (fig.58), Matisse assimilates Cézanne's technique of using colour relationships and lines to create what he called an 'expansive force'. But, as in Cézanne, this expressive, gestural quality has an effect that the artist saw as 'balance' and 'serenity'. Partly, this is a feeling corresponding to the 'harmony' Matisse gave the 'entire arrangement' of his painting. But, as in Cézanne's 'Three Bathers', Matisse also fits his figures to the framing edge to specify a feeling of restraint. He also induces a feeling of tension in the detail where the momentum of the dance threatens to pull apart the hands that two dancers extend to each other. In other words, as with Cézanne's hands, Matisse's represent here what the whole painting expresses.

Both Picasso's and Braque's early Cubism also takes from Cézanne its way of making touch the primary expressive feature of the painting. But, more explicitly than Matisse, they were concerned to arrive at this way of painting by declaring frankly the conventional or arbitrary character of the painting. Picasso first used Cézannian devices to declare the autonomous identity of the work of art 'Les Demoiselles d'Avignon' (fig.59) (the title refers to the 'young ladies' of the prostitute quarter in Picasso's native Barcelona). For instance, Picasso uses a blue, floating contour around the right leg of the leftmost *demoiselle*, as if to declare that a pictorial element need not resemble what it represents in order to do its job. Similarly, he models the torso of the second *demoiselle* in brown lines and the torso of the third in white, to emphasise how lines are, finally, lines. However, other devices Picasso developed on the back of Cézanne's work are used to give the figures and their space a strongly tactile quality. These include Picasso's use of passage (or spatially indeterminate planes), a splayed perspective (particularly in the right demoiselle culled from Cézanne's 'Three Bathers'), a 'solid' background, the analysis of forms into facets, and so-called multiple viewpoint. Cumulatively the effect of such devices is to create a shallow, ambiguous space behind, but also in front of the picture plane, in which the depicted world has a strongly sculptural feel. As Picasso explained later, with reference to his still lifes:

If we think of an object, let us say a violin, it does not appear before the eye of our mind as we would see it without bodily eyes. We can, and in fact do, think of its various aspects at the same time. Some of them stand out so clearly that we feel we can touch and handle them; others are somehow blurred. And yet this strange medley of images represents more of the 'real' violin than any single snapshot or meticulous painting could ever contain.

Braque quickly assimilated the lessons of 'Les Demoiselles d'Avignon' to his own understanding of Cézanne, and developed his own style from this, although it had qualities similar to Picasso's. As he later explained about his involvement in Cubism:

What particularly attracted me … was the materialisation of this new space that I felt to be in the offing. So I began to concentrate on still lifes, because in the still life you have a tactile, I might almost say a manual space … This answered to the hankering I have always had to touch things and not merely see them. It was this space that particularly attracted me, for this was the first concern of Cubism, the investigation of space.

Subsequent developments in *papier collé* led Picasso and Braque away from the tactility to a concern to make the arbitrary character of representation the subject of the work. But it was their common concern to show how seeing involves 'grasping' an object with the eye that most fully illustrates how they assimilated Cézanne's work. It might even be said that the importance of touch in Cézanne's work is greater than Matisse, Picasso or Braque realised. For one thing, it illustrates how some art expresses a vision of a sociality that is right, or desirable, and in such a way that it entreats its spectators to act it out. After all, imagining touch is about imagining meeting the world outside ourselves, and particularly the social world. And Cézanne often wished a correspondent a 'handshake' at the end of his letters, not just casually, but in the hope of continuing their discussion on art 'face to face'. Moreover, the way that Cézanne figured touch in his paintings easily permits the spectator to imagine the kind of sociality – mutual give and take, respect for community, etc. – that it expresses the hope of.

However, it must be remembered that what a Cézanne expresses is a metaphorical property of the painting, and is irreducible to words – which is why Cézanne could not tell Gasquet what he meant by 'my canvas joins hands', only show him. But this is not to say that it is inappropriate to try to interpret verbally what Cézanne painted. In fact, the opposite is true. For one thing, we cannot see the work for what it is without interpreting it with the aid of appropriate concepts. However, the rub here is that saying what a radically original work of art expresses is not simply a matter of inventing words with which to describe its effects. It also involves developing new social practices and institutions in which these words can have currency and meaning – after all, a word cannot mean anything unless there is a social context in which it can be used. By this account, the picture can remain a dead sign unless it contributes to the formation of new forms of life through the vision of sociality that it expresses. This means that seeing and interpreting Cézanne ultimately involves a challenge to our politics.

The idea that Cézanne's art, in being itself, becomes a potential source of new forms of life may seem strange. Certainly, many Modernist artists and theorists have missed this point, or have treated it as a paradox. Perhaps, therefore, the best comment on Cézanne's legacy is Picasso's remark of 1923: 'Through art we express our conception of what nature is not'. Taken one way, it is a statement of the absolute autonomy of art. Taken another way, it suggests that in demonstrating the difference between itself and life, art like Cézanne's and his followers' shows what life might be like.

fig.59
Pablo Picasso
**Les Desmoiselles d'Avignon** 1907
oil on canvas 243.9 × 233.7 cm
The Museum of Modern Art, New York.
Acquired through the Lillie P. Bliss Bequest

# CHRONOLOGY

1839
Cézanne's father, Louis-August Cézanne, establishes his hat business in Aix-en-Provence. 19 January, Paul Cézanne is born.

1848
*July Revolution. The Second Republic.* Cézanne's father founds the Bank Cézanne & Cabasol in Aix.

1849
The Aix Museum receives a bequest from the local artist, François Granet, which later forms the collection studied by Cézanne. Cézanne enters the Pensionnat Saint-Joseph (where he stays until 1852). Here meets **Henri Gasquet**.

1852
*The Second Empire is established.* Cézanne enters the Collège Bourbon. Befriends **Paul Alexis**, **Baptiste Baille** and **Emile Zola**.

1857
First works at the Free Municipal School for Drawing in Aix. The poet **Charles Baudelaire** publishes *The Flowers of Evil*.

1858
February, Zola leaves for Paris and returns to Aix for summer. July, Cézanne fails his baccalaureate, but passes in November.

1859
Studies law reluctantly at the University of Aix, while dreaming of becoming a painter. Obtains a second prize for a painted figure subject at the Free Municipal School of Drawing. Father buys the **Jas de Bouffan**, the artist's home until 1899.

1861
Abandons his studies in law. April to autumn, in Paris for the first time. Works at the informal studio, the Académie Suisse, where he meets the future Impressionist, **Camille Pissarro**. September, returns to Aix and begins work in his father's bank.

1862
*Wagner's* Tannhäuser *mounted at the Paris Opéra.* Cézanne leaves his father's bank and takes up painting again. Friendship with the painter **Numa Coste**. November, fails entrance examination to Ecole des Beaux-Arts. Returns to Aix.

1863
Returns to Académie Suisse. Meets the future Impressionists **Claude Monet**, Armand Guillaumin, Frédéric Bazille and Alfred Sisley, the painters Antoine Guillemet and Francisco Oller, and the literary critic **Marius Roux**. Exhibits at the Salon des Réfusés where **Edouard Manet**'s 'Luncheon on the Grass' ('Déjeuner sur l'herbe') creates a scandal. November, registers as a copyist in the Louvre.

1864
Rejected by the Salon, the major officially sponsored annual art exhibition. August, in **L'Estaque** (a fishing village near Marseilles).

1865
Rejected by the Salon. Late summer, returns to Aix. Friendship with the painters **Antony Valabrègue** and **Antoine-Fortuné Marion**.

1866
Rejected by the Salon, writes a letter of protest to the Director of Fine Arts demanding the reinstatement of the Réfusés. Manet compliments Cézanne on his still lifes. Zola publishes articles in *L'Evénement*. July, Cézanne working out-of-doors at Bennecourt. Guillaumin persuades Cézanne's father to increase his allowance .

1867
Rejected by the Salon. A painting exhibited in Aix is withdrawn owing to public hostility. Visits the café Guerbois, where Manet, the future Impressionists and the Provençal painter Paul Gigou gather.

1868
Rejected by the Salon. Given permission to copy in the Louvre as a pupil of Chesneau.

1869

Rejected by the Salon. Meets his future wife, **Hortense Fiquet**, a nineteen year old artist's model. Reads Stendhal's *History of Painting in Italy*.

1870

The portrait of Cézanne's friend, the painter **Achille Emperaire**, and other paintings rejected by the Salon. *Franco-Prussian war begins. Napoleon III abdicates and the Third Republic is declared.*

1871

*January, armistice signed. Paris Commune from March to May.* Cézanne lives in a house with the sculptor **Phillipe Solari**.

1872

Rejected by the Salon. Cézanne's son is born and is christened Paul. The Cézanne family moves to Pontoise, and eventually settles in Auvers.

1873

Friendship with the collector and friend of the Impressionists, **Dr Gachet** begins. The critic Théodore Duret becomes interested in Cézanne's work. Zola publishes *The Belly of Paris* in which the painter, Claude Lantier, resembles Cézanne.

1874

Exhibits three paintings (including 'The House of the Hanged Man' and 'A Modern Olympia') at the first Impressionist exhibition.

1875

Possibly has a watercolour rejected by the Salon. Meets the collector **Victor Chocquet**, who had bought a painting by Cézanne from the dealer, *Père* Tanguy. Lives in Paris near Guillaumin, with whom he works.

1876

Declines to exhibit at the second Impressionist exhibition, but is rejected by the Salon. Exhibits at the second Impressionist exhibition. Chocquet buys two paintings.

1877

Exhibits sixteen works at the third Impressionist exhibition. A portrait of Chocquet is praised by the critic, Georges Rivière. Other critics hostile to Cézanne. Works with Pissarro at Pontoise.

1878

Rejected by the Salon. Works in Aix and L'Estaque the whole year. *Exposition Universelle in Paris.*

1879

Rejected by the Salon, despite the intervention of Guillemet (who is now on the Jury).

1880

Probably rejected by the Salon. Meets the critic Joris-Karl Huysmans at Zola's house at Médan.

1881

Probably rejected by the Salon. Works in Pontoise with Pissarro from May to October. Meets the painter **Paul Gauguin**.

1882

Works in L'Estaque with Renoir. Accepted at the Salon as a 'pupil' of Guillemet. Exhibits a portrait of a man.

1883

Rejected by the Salon. Meets Monet and Renoir in the south. Gauguin buys two paintings from Tanguy.

1884

Rejected by the Salon. The painter Paul Signac buys a painting from Tanguy.

1885

Probably rejected by the Salon. Has a mysterious infatuation. Works at **Gardanne**, near Aix.

1886

March, Zola publishes *The Masterpiece*. Its main character, Lantier, offends Cézanne. Breaks off friendship with Zola. April, marries Hortense Fiquet. May, last Impressionist exhibition. October, Cézanne's father dies. Cezanne is now financially independent.

1888

Huysmans publishes an article on Cézanne in *La Cravache*. Cézanne mentioned in other Symbolist magazines.

1889

Invited by the avant-garde Belgian group, Les XX, to exhibit in Brussels. Renoir works in Aix.

1890
Shows three paintings with Les XX. Begins to suffer from diabetes.

1891
Sees Alexis frequently. Returns to the Catholic religion.

1892
The critic Georges Lecomte publishes a lecture given at Les XX on Cézanne in *L'Art moderne*. The painter **Emile Bernard** publishes a short pamphlet on Cézanne.

1894
Spends autumn with Monet at Giverny and meets the Impressionist painter **Mary Cassatt**, Rodin, and the critic **Gustave Geffroy**. The dealer **Ambroise Vollard** buys several Cézannes from Tanguy's estate.

1895
Vollard opens Cézanne's first one-man show. Cézanne sends him 150 works. Two paintings by Cézanne enter the Luxembourg Museum with bequest to the state of the collection of the Impressionist Gustave Caillebotte.

1896
Meets the young poet **Joachim Gasquet**. Through Gasquet, Cézanne meets **Louis Aurenche**. Zola dubs Cézanne an 'abortive genius'.

1897
Vollard buys the contents of Cézanne's studio near Fontainbleau. Cézanne opposes Zola's defence of Dreyfus.

1898
Works sometimes with the young painter **Louis le Bail**.

1899
Meets Egisto Fabbri, an Italian collector who owns sixteen Cézannes. Paints a portrait of Vollard. Exhibits three paintings at the open exhibition of the Parisian avant-garde Société des artistes indépendants. Cézannes fetch good prices at the sales of the Chocquet and Count Doria collections. The dealer Durand-Ruel is one of the buyers. Vollard holds a one-man exhibition and tells Gauguin he has bought the entire contents of Cézanne's studio.

1900
The critic Roger Marx ensures three Cézanne paintings are shown at the Centennial Exhibition in Paris.

1901
Shows with the Indépendants and the Brussels group, La Libre Esthétique. Buys land on the Chemin des Lauves outside Aix to build a studio. Meets the poet **Léo Larguier** at Joachim Gasquet's.

1902
Exhibits three works at the Indépendants upon the insistence of the painter **Maurice Denis**. Spends several weeks with Gasquet. Vollard visits Cézanne in Aix. The dealer Bernheim-Jeune buys works from Cézanne's son. Visited by the young archaeologist, **Jules Borély**.

1903
Zola's collection sold. Cézanne violently attacked in the press. Exhibits in Berlin and Vienna.

1904
Bernard visits Cézanne in Aix. Exhibits at La Libre Esthétique and the Salon d'Automne in Paris. Visited in Aix by the young artists, **Charles Camoin** and Francis Jourdain.

1905
Visited by the artists Maurice Denis, K.-X. Roussel, and **R.P. Rivière** and **Jacques Schnerb**. Exhibits at the Salon d'Automne. Durand-Ruel exhibits Cézanne in London at the Grafton Galleries.

1906
Visited by Karl Ernst Osthaus who buys two paintings. Exhibits at the Société des amis des arts in Aix as a 'pupil of Pissarro'. Shows at the Salon d'Automne. Reading Baudelaire's *Romantic Art*. Visited by Camoin. Dies on 22 October.

1907
Seventy-nine of Cézanne's watercolours are exhibited at Bernheim-Jeune's. The Cézanne memorial exhibition at the Salon d'Automne shows fifty-six works. **Henri Matisse**, **Pablo Picasso** and **Georges Braque** are impressed by Cézanne's works.

# Select Bibliography

## Catalogues Raisonnés

Chappuis, Adrien, *The Drawings of Paul Cézanne: A Catalogue Raisonné*, Greenwich, Connecticutt and London 1973.
Rewald, John, *Paul Cézanne: The Watercolours*, New York and London 1983.
Venturi, Lionello, *Cézanne, son art, son oeuvre*, Paris 1961, 2 vols.

## General

Gowing, Lawrence (ed.), *Cézanne: The Early Years 1859–1872*, London and Washington, D.C. 1988 and 1989.
Rubin, William (ed.), *Cézanne: The Late Work*, New York 1978.
Wechsler, Judith, *Cézanne in Perspective*, Englewood Cliffs, New Jersey 1975.

## Letters and Witness Accounts

Doran, Michael (ed.), *Conversations avec Cézanne*, Paris 1978: includes accounts by Bernard, Borély, Denis, Gasquet, Geffroy, Larguier, Rivière and Schnerb, and Vollard.
Kendall, Richard, *Cézanne by Himself*, London and Sydney 1988.
Rewald, John (ed.), *Cézanne Letters*, New York and Oxford 1976.

## Biography

Mack, Gerstle, *Paul Cézanne*, New York 1935.
Rewald, John, *Paul Cézanne*, New York 1948.

## Formalism

Bell, Clive, *Art*, London 1914.
Fry, Roger, *Cézanne: a Study of his Development*, London 1927.
Loran, Earl, *Cézanne's Composition*, Berkeley and Los Angeles 1943.

## Psychoanalysis

Reff, Theodore, 'Cézanne's "Dream of Hannibal"', *Art Bulletin*, vol.45, 1963, pp.148–52.
Schapiro, Meyer, 'The Apples of Cézanne: An Essay in the Meaning of Still Life' in *Modern Art: 19th & 20th Centuries*, New York 1978.

## Studies of Imagery

Krumrine, Mary Louise, *Paul Cézanne: The Bathers*, Basel and London 1989–90.
Lewis, Mary Tompkins, *Cézanne's Early Imagery*, Berkeley, Los Angeles and London 1989.
Reff, Theodore, 'Cézanne, Flaubert, Saint Anthony and the Queen of Sheba', *Art Bulletin*, vol.44, 1962, pp.113–25.

## Studies of Technique and Theory

Ratcliffe, Robert W., 'Cézanne's Working Methods and their Theoretical Background', unpublished Ph.D. thesis, University of London 1960.
Shiff, Richard, *Cézanne and the End of Impressionism: A Study of the Theory, Technique, and Critical Evaluation of Modern Art*, Chicago and London 1984.

## Aesthetics

Shiff, Richard, 'Cézanne's Physicality' in S. Kemal and I. Gaskell (eds.), *The Language of Art History*, Cambridge 1991.
Stokes, Adrian, *Cézanne*, London 1956.
Wollheim, Richard, 'Adrian Stokes' in *On Art and the Mind*, London 1973.
Wollheim, Richard, *Painting as an Art*, Washington, D.C. and London 1987.

# Photographic Credits

# Index